IMAGES
of America

NEWBURGH
THE HEART OF THE CITY

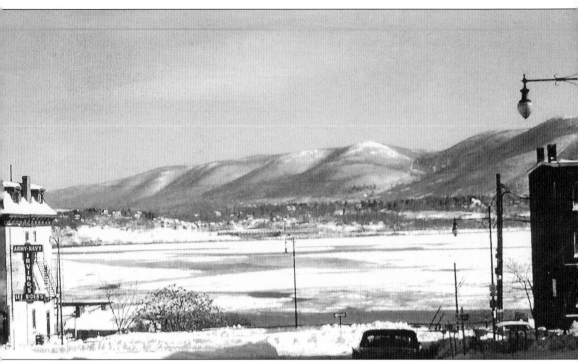

This 1968 photograph, taken near the foot of Broadway, shows a magnificent view of the Hudson River and the mountains on its east bank. The steep grade of Broadway at this point prohibited its direct extension to the river. Colden Street, on the left, was the main thoroughfare to Water Street, connecting with small streets leading to the riverfront. (Daley photograph and collection.)

On the cover: This photograph of World War I veterans marching down Broadway was given to the Historical Society of Newburgh Bay and the Highlands by Elinor Johanson, whose late husband, Herbert Johanson, had furnished her with some additional information about the scene (see page 51).

IMAGES
of America

NEWBURGH
THE HEART OF THE CITY

Patricia A. Favata

ARCADIA

First published 2004
Reprinted 2004

Published by Arcadia Publishing,
Charleston SC, Chicago IL, Portsmouth NH, San Francisco CA

Printed in Great Britain

Library of Congress Catalog Card Number: 2004102947

For all general information, contact Arcadia Publishing:
Telephone 843-853-2070
Fax 843-853-0044
E-mail sales@arcadiapublishing.com
For customer service and orders:
Toll-free 1-888-313-2665

Visit us on the Internet at www.arcadiapublishing.com

This book is dedicated to the memory of Robert E. Decker, who left us in 2003. He loved his family, his work in the oil business, local history, and travel. He served as president of the Calvary Presbyterian Church and was a longtime member of the Board of Directors of the Historical Society of Newburgh Bay and the Highlands. Above all, he was a good friend and is sorely missed by all who knew him. (Favata photograph and collection.)

CONTENTS

ACKNOWLEDGMENTS

The best part about working on this book was the time spent renewing old friendships and meeting new people, all with one common interest: their love of Newburgh. I am extremely grateful for the help I received in completing this project.

For providing photographs and other assistance, I thank the following: Ralph Aiello, premier photographer and wonderful person; Tom Daley, another expert documentary photographer and friend; Bob and Vivian Goodbread, who opened their collections and home to me on many occasions; George Linton, who took some of Goodbread's photographs and helped him with his collections; David and Mary McTamaney, old elementary school friends who allowed me use of early family pictures; Mary Hafer and Mary Lou Kelly, Archie Stewart's daughter and niece, respectively, who donated more than 50 of Stewart's photographs to the Historical Society of Newburgh Bay and the Highlands when they learned of this book; Elizabeth McKean, friend and records management officer for the city of Newburgh, who allowed me use of the city's archives; Carla Decker, a dear friend who gave me access to Robert Decker's postcards; Jack Flannery, a very patient man; Marlene and Bob Jordy, fellow postcard collectors; Agnes and Al Cavalari, also old postcard friends; Paul Yablonsky, avid Newburgh collector of postcards and family photographs, including those of his cousin Joyce Hansen; Walter Whitehill, who was willing to share his Newburgh collection; Dennis Collins, who brought in photographs and firemen's information; the Galatis, who allowed the use of some of their family collections; Louise Hargrave, who shared her photographs and memories; Tom Fogarty, who let me borrow his slides; Jack Carlstrom, a kind and gentle man who shared his photographs; Kathleen Stradar, who offered the photograph of her father's shoe store and the book it came from; Agnes Koerber, Cathy Masztalics, and Winnie Mazzarelli of Grace Church, who helped secure photographs from the church archive, including those by Stanley Cook; Kim Bloomer, a Newburgh collector who shared his photographs; Frederica Warner, a friend who loaned me the photograph of her father; Marshall Rosenblum, who loaned me the images of his father's store; Anthony Cracolici, an active member of the Knights of Columbus who loaned a photograph; George Koundounas, who took photographs off the wall of his restaurant to let me scan them; Mayor Nick Valentine; Mary Jane Miller, who shared her family portrait and story; Mickey Snyder, who shared store photographs; Millie Starin, who loaned a photograph of her husband's business; Elinor Johansen, who offered a World War I photograph; Trish Haggerty-Wenz, who loaned Hotel Newburgh photographs and information; "Animal" Hughes, who dated photographs and provided contacts; Eugenia Frangos; and the Newburgh Free Library staff.

I thank Russell Lange for his technical expertise and, for their willingness to do my regular job at the historical society and help in any way they could, Jim Halpin, Cathy Plumbstead, and Maureen Belden. The following helped in many other ways: Allyn Lange, Emil and Nettie Gironda, Assistant Chief Michael Ferrera, Kiki Hayden, Rev. Campbell Thompson, Betty Reed, Lieutenant Fischer, Carol Cummings, Ruth Valenti, Gene Embler, Mary Torrens, Mel Johnson, Heidi Benson, Margaret Dillon, and Mary Murphy.

Three people helped me repeatedly when I thought I could no longer continue this project. I offer my sincere gratitude to Mary McTamaney, Betsy McKean, and Bob Goodbread, for providing answers when I could find none and aiding in research. Finally, to Al and Buffey, thank you for being there and providing support when I needed it.

Introduction

A few years ago, as the volunteer librarian-archivist at the Historical Society of Newburgh Bay and the Highlands, I began to arrange our thousands of photographs into some logical order. As I hunted and collected, I was amazed at not only the number and the quality, but the "face" they gave our local history. I kept saying to myself, "Someone should write a book and share some of these pictures."

Rob and Carla Decker and my husband, Al, and I long shared a love of local history and an involvement with the historical society. After Rob Decker died, I wanted to do something in his memory that would benefit the society. I thought of the photographs and decided to try to use some of them in a book. When friends heard of the idea, they offered their collections and told me of others who had wonderful Newburgh photographs.

After talking to my friend Kate Lindemann, I decided the topic of the book would be Broadway because, for me, it has always been the heart of the city. I also chose to limit the majority of images to the 20th century because so little history of that period has been captured in any format other than newspapers.

In order to give some context to *The Heart of the City*, it is necessary to know a little history of Broadway. In 1719, Alexander Graham was hired by the first group of immigrants, the Palatines, to travel to Newburgh and make a map of the settlers' property. In addition to giving every man, woman, and child 50 acres of land, he created a road toward the south end of the property that was 8 rods, or 132 feet, wide. It was called Western Avenue, reflecting the fact that it was the original "cow path" to the west.

In 1801, shortly after the village of Newburgh was formed, the Newburgh-Cochecton Turnpike Company was founded. Improved by the company, Western Avenue became the first link of the Cochecton Turnpike, which extended to the Delaware River, almost 50 miles away.

The turnpike was the thoroughfare for those receiving commercial goods and supplies from the sloops of the Hudson. In return, farmers would use the same road system to send their produce and other farm products to the ships for sale in other locations, primarily New York City. Even after the advent of canals and rails provided other means to send supplies to the west and farmers' goods to the east, traffic remained heavy on the turnpike.

Throughout the 19th century, there were plans and discussions on ways to extend Broadway to the river. Broadway is even seen on some early maps as extending to Water Street, but the steep grade from Water to Colden and Washington Place prohibited any traffic other than foot. Remnants of one of the two winding pedestrian staircases can still be seen.

In 1880, the Common Council adopted the name Broadway for the street. As reports of the time explain, the reason for the name change was, "It was the natural name for a street with most of its 11,150 foot length at 132 feet wide."

The next major change to come to Broadway involved the Newburgh Street Railway plan to build and operate a "surface" road from near the western city line down Broadway to Union Depot on the riverfront. A branch between Broadway and Renwick Street to the south was also planned. After completion, the trolley had its first run on December 26, 1886, with great fanfare. This action opened up large tracts of land for development and offered the expanding population and businesses options as well.

The advent of the automobile caused major change on Broadway. By the late 1920s, the trolley was gone and car dealerships dotted Broadway. This new mode of transportation allowed

people the freedom to travel in all directions, and the street benefitted immensely from the traffic. Broadway became populated to the city limits. Old businesses moved from the waterfront, and new ones were opened. The street grew and prospered during the Depression and World War II.

In the 1950s, Broadway was the hub of commercial and social activity for Newburgh and the surrounding areas. With the coming of the malls to suburbia in the late 1960s, business slowed on Broadway. A welfare scandal and civil unrest, around the same time, caused more businesses and longtime residents to leave. The loss of Stewart Field Air Force Base and removal of factories also had an impact. Newburgh, like so many other older small cities in the Northeast, found itself in a period of decline. Broadway suffered. Proposal after proposal for an improved Broadway was unfunded or failed. The status quo lasted until the last two decades of the century.

Since then, new structures have been built, others renovated, and still others have experienced adaptive reuse. About 70 percent of the buildings constructed on Broadway between 1880 and 1950 are still extant.

A few long-running businesses still operate on Broadway. In the last 30 years, new residents and immigrants have followed the traditions of the past and are working hard to make their establishments successful.

These changes are inevitable, as we will see from this walking tour of the last century. I hope you enjoy this little book and that it will bring back some of your best times in Newburgh.

One

COLDEN STREET TO THE BROADWAY THEATRE

The oldest section of Broadway, this area has experienced the most change during the 20th century. Some of these changes can be attributed to the weather, some to disasters such as fire, others to urban renewal, and still others to decisions made by city government. At the beginning of the century, the majority of structures on these blocks had been constructed. Some businesses and institutions in other parts of the city, primarily on the waterfront, needed room for expansion. Examples are the Rosenblums, Ware-House Furniture, VanCleft Hardware, the Columbus Trust Company, and city hall. They chose heavily traveled Broadway because of its larger buildings. In these cases, the buildings were extensively renovated to suit the clients' needs. This adaptive reuse was constant throughout the century and continues today.

Another change in appearance for the area was due to disaster, like the fires that took place in the Academy and Broadway Theatres. A hurricane forced a shrinking congregation at St. John's to another location because parishioners could not afford to fix their old church.

In what is a large part of the overall story of Newburgh in the 20th century, the Urban Renewal Agency condemned and demolished many properties, including the structures on the south side of Broadway's first block. Other structures now gone from the landscape are the result of ill-fated attempts by the city and individuals to provide more parking with the hopes of revitalizing downtown businesses.

Today, there are many hopeful signs for the future on these blocks: Orange County Community College occupies the site of Ware-House Furniture and some of the church land, the public safety building stands on urban renewal lands, city hall has been extensively remodeled, the Karpeles Museum is in the former Savings Bank, and Safe Harbors and the Cornerstone occupy the Hotel Newburgh site and have recently held a live performance at the Ritz Theatre.

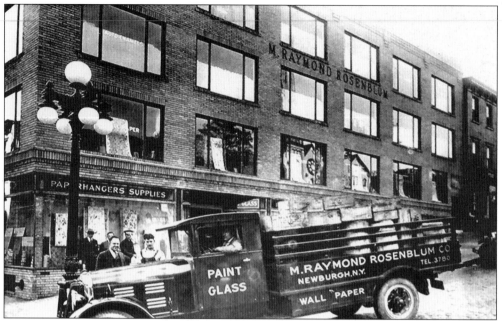

In 1927, Newburgh architect J. Percy Hanford transformed the Walter Renker's Plumbing building into a modern structure to house the M. Raymond Rosenblum Company, a quality paint and wallpaper store. Rosenblum, who had three previous Newburgh locations, remained on Broadway until the Urban Renewal Agency took title to the property. The company then moved to upper Broadway into the former A & P building. The original Broadway location now holds residences and the Public Safety Building. (Rosenblum collection.)

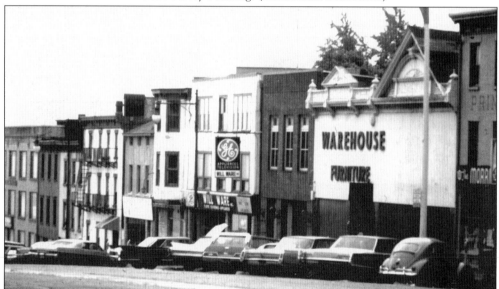

In 1973, the first block on Broadway looked like this. Some buildings were boarded up; others, like Morris Printing, were still conducting business. Still others, such as the building with the fire escape and the building on the right of Will Ware, had been closed and vandalized. Having been condemned by the Urban Renewal Agency, the majority of the block was demolished a short time later. (Daley photograph and collection.)

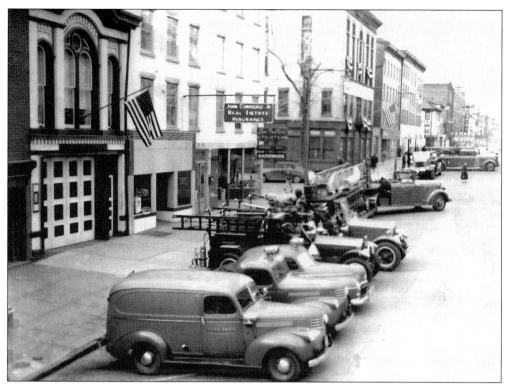

Fire department vehicles and apparatus line the south side of Broadway from the front of the firehouse to city hall during the All-America City celebration in 1952. The ladder truck, at the corner of Grand Street, was purchased in 1939 for $27,000 and had a 100-foot ladder. (Historical Society of Newburgh Bay and the Highlands collection.)

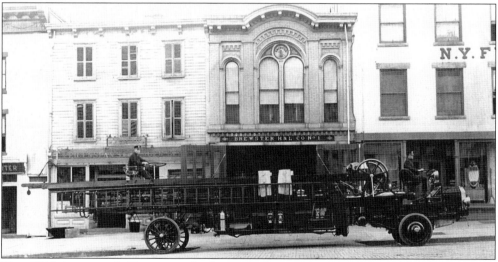

This 1915 American LaFrance standard-type 31 front-drive tractor with four-cylinder engine was one of the first pieces of motorized apparatus used by the fire department. Here, it is parked in front of Brewster Hook and Ladder, at 75 Broadway. Built in 1862, the firehouse was designed by architect John Kelly and was used by the fire department for 104 years before closing in 1976. (Historical Society of Newburgh Bay and the Highlands collection.)

Lafayette Hunter was working as a waiter in the Palatine Hotel when his church, the African Methodist Episcopal Zion Church, asked him to become its secretary. In order to learn shorthand, Hunter enrolled at the Spencerian Business School, becoming the first person of color to take courses there. This was "unheard of" in the early part of the century, according to his daughter, community volunteer Frederica Warner. (Warner collection.)

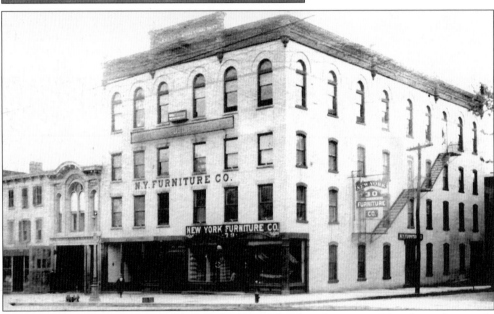

In 1897, Joseph Van Cleft remodeled the buildings that bear his name. They housed not only the Spencerian Business School but also hundreds of other ventures during the 20th century. In the photograph, New York Furniture Company, "Home of Artistic Furniture," is visible. Others to occupy the building throughout the years included insurance companies, a dentist, doctors, lawyers, and even a hosiery company. Currently, the principal tenant is a chiropractor. (Historical Society of Newburgh Bay and the Highlands collection.)

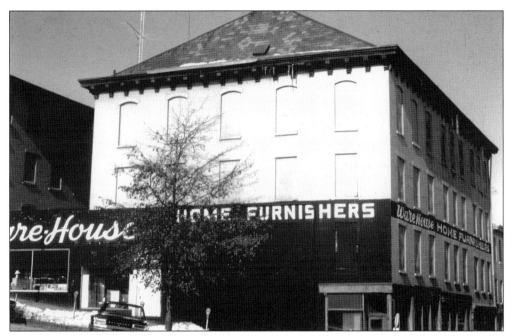

Ware-House Furniture's main building was located at the foot of Broadway on the north side. A former electrical supply house and dry cleaner, the building had five floors including a basement and no elevator. The Levin family opened its furniture store there in 1935. Below, founder Larry Levin looks at the large selection of rugs offered. In addition to carpeting, the store had rooms stock full of single items such as cribs, chairs and sofas, and bedroom sets. In 1935, during the Depression, Ware-House Furniture had a special "we will not be undersold" $49 sale. For that price, one could buy a four-piece Krohler living room suite, a three-piece bedroom suite, or a six-piece walnut dining set. (Galati family photographs and collection.)

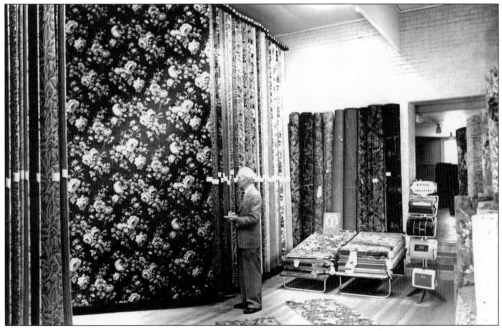

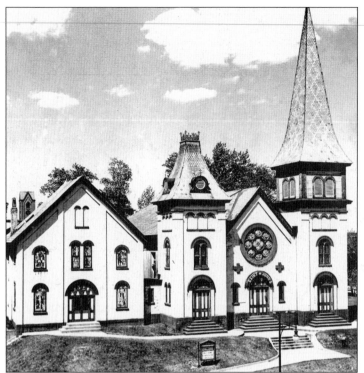

St. John's Methodist Church was built in 1841 on a large plot of land on the north side of Broadway just west of High Street. At the beginning of the 20th century, the church had more than 600 members. A hurricane severely damaged the structure in 1950, at the same time that the membership was declining. As a result, the congregation merged with the First Methodist Church in 1955. Shortly thereafter, the church was demolished. (Historical Society of Newburgh Bay and the Highlands collection.)

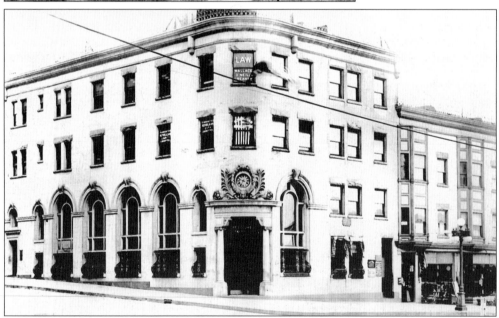

The Columbus Trust Company was chartered in 1892, the 400th anniversary of Columbus's discovery of America. The bank's board of directors and founders considered it "only fitting to name the bank after a man whose principles were similar to those of which the bank was founded on." In 1902, the bank moved to Broadway after renovating Robert Hyndman's family grocery store. Within the next few years, the bank bought the adjacent building on Grand Street and unified the façade. (Stradar collection.)

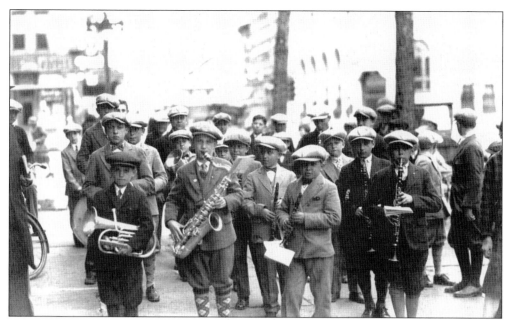

This charming photograph shows a boys' band (with large instruments) on the Grand Street side of city hall in the early 1920s. Although the name of the band and its participants could not be found, it could be one of the three boys' bands that existed at the time: Ortone's, Schofield's, or the Junior Holy Name. (Whitehill collection.)

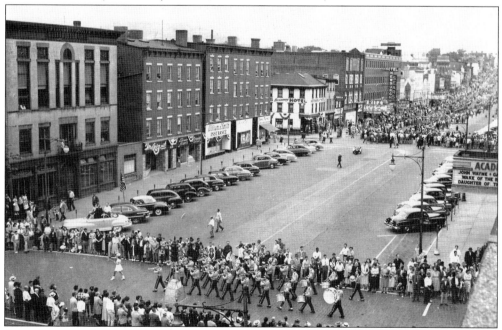

A patriotic parade in 1949 took a turn on Liberty before crossing Broadway again at Grand Street, probably to end at Washington's Headquarters, a very common practice that still takes place. John Wayne's nautical movie *Wake of the Red Witch* was playing at the Academy while thousands of Newburghers lined the street to watch the parade. (Aiello photograph, Historical Society of Newburgh Bay and the Highlands collection.)

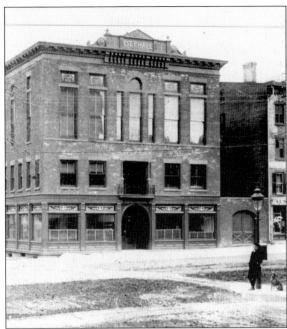

A boy and his dog pose at a lamppost across from city hall. Formerly Louis Bazzoni's carriage shop, the building became city hall in the late 1890s. This is a *c.* 1900 photograph because Broadway is not yet paved. In 1904, after much discussion and the laying of new trolley tracks, Broadway was paved from Colden to Mill Streets. (Historical Society of Newburgh Bay and the Highlands collection.)

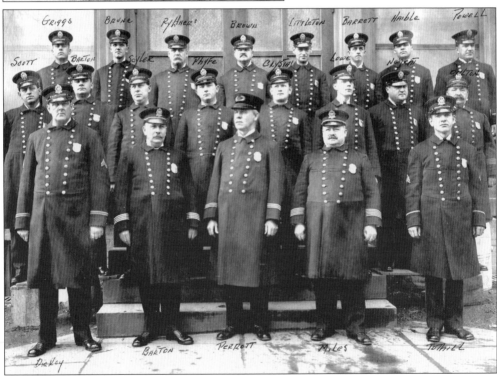

Also *c.* 1900, this photograph of the police department was taken in front of the Grand Street entrance to city hall, where police headquarters was located. Chief Emanuele Perrott appears in the center, first row. Chiefs can always be identified and dated by the style of their caps. Perrott was chief of the department from 1895 to 1918. (Historical Society of Newburgh Bay and the Highlands collection.)

16

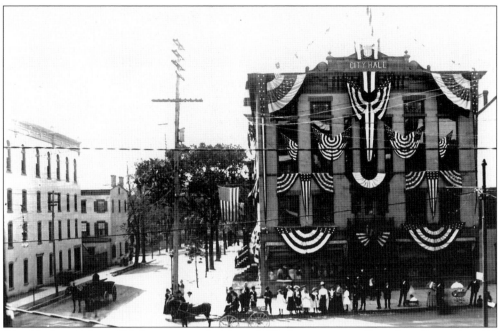

The Hudson-Fulton Celebration was held in 1909, beginning on Saturday, September 25. Sunday was devoted to religious observances. On Monday, Old Home Week began with family reunions and various receptions. On Wednesday, the statue of Gen. Anthony Wayne was dedicated at Washington's Headquarters. On Thursday, Firemen's Day, a monument to the city's volunteer firemen was unveiled. October 1 was Hudson-Fulton Day, with a national naval parade amassing at Newburgh that proved to be the city's largest. Saturday was Aquatic Day, devoted to sailboat, motorboat, and yacht racing on the Hudson. The week-long ceremonies came to an end with the lighting of the Beacon Fires on Saturday evening. During the week, all city buildings were proudly decorated and illuminated in the evening (below), becoming the first time in local history that electricity was used to drape buildings in light in the nighttime. (Historical Society of Newburgh Bay and the Highlands collection.)

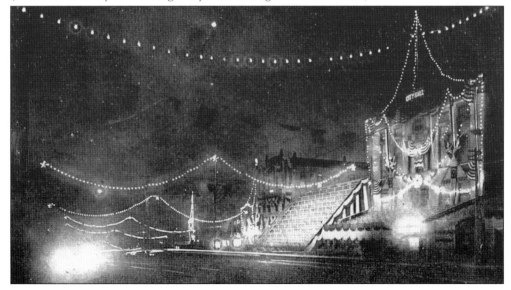

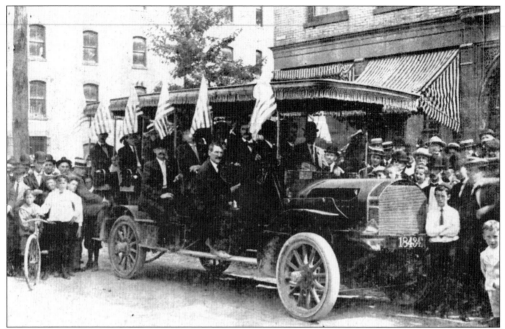

Before World War I, the automobile was threatening the very existence of the Newburgh trolley. However, the trolley men called a strike to demonstrate to the citizens how important their mode of transportation was and to demand better wages. Here, they pose in front of city hall during the strike. Their cause was fruitless, and by 1927, the trolley was only a memory. (Whitehill collection.)

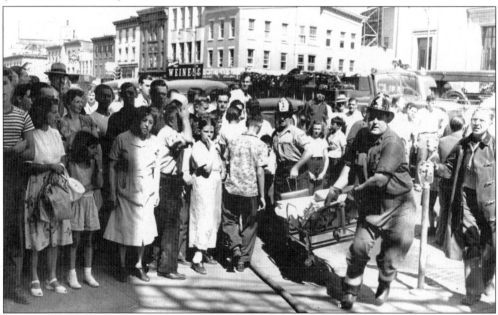

Concern shows on the faces of onlookers as fireman Ferd Ritz (foreground) runs a stretcher toward city hall. Dale Coleman helps Ritz, as fireman Gus Trache (far right) looks on. A few years later, Engine No. 4 (background) was involved in a fiery crash in front of Newburgh Free Academy, the local high school. (Goodbread collection.)

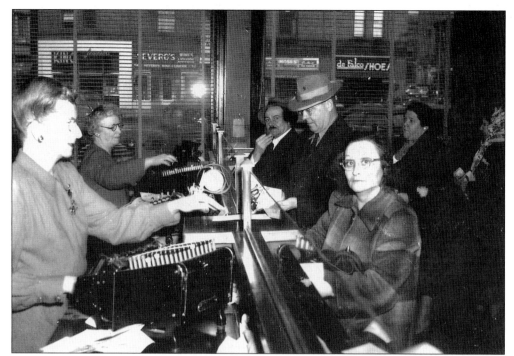

Newburgh citizens stand in line to pay their taxes at the city clerk's office in this 1950s photograph. In the foreground is Lillian Flemming, a longtime clerk in the office. No computers were used in those days, only bulky adding machine and calculators. However, one thing remains the same: no one looks happy at tax time. (Goodbread collection.)

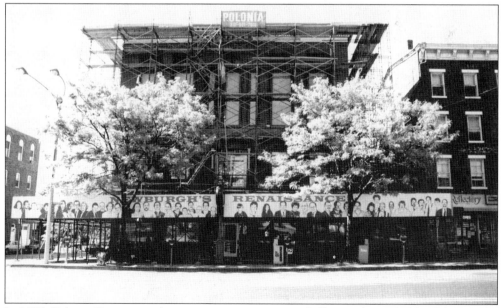

In 1997, Polonia Restoration began a project to give city hall a much-needed facelift. In order to call attention to the project, Gerry Sanchez, Polonia's president, had a mural created depicting many of city hall's personalities. The mural, wrapping around two sides of the building, was the subject of much discussion during the period. (Favata photograph and collection.)

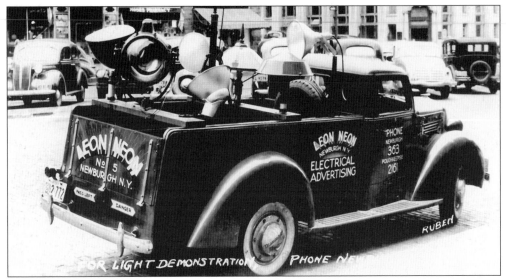

This 1939 Ford utility truck is outfitted with high-powered lights to provide lighting for many varied outdoor events. Louis Tarr was the manager of Leon Neon, a company specializing in all types of lighting, sign-painting, and early electronics. The business was located at 77^{1}/$_{2}$ Broadway for many years. (Ruben photograph, Jordy collection.)

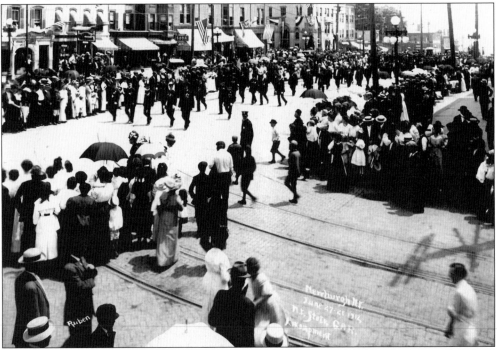

Members of the Grand Army of the Republic (GAR), veterans of the Civil War, proudly march past the Academy of Music Theatre and the shops between Grand and Liberty Streets on their way to Washington's Headquarters to participate in the day's closing ceremonies. A large contingent of the local GAR constituted the 124th New York State Volunteers, whose nickname was "the Orange Blossoms," last under the command of Col. Charles Weygant. (Whitehill collection.)

This rare postcard from the early part of the century gives a wide-angle view of both sides of the street as the trolley heads west. The Academy Candy Kitchen, a popular sweet shop, occupied the corner store. The top two floors of the Academy Theatre were the home of the Masonic Lodge. The first floor housed mainly professional offices, and other shops at street level included a pharmacy, a clothing shop, and a dry goods store. (Yablonsky collection.)

Opened in 1888, this "temple of amusement" played host to some of the country's best-known actors and actresses including Edwin Booth, Maurice Barrymore, and Helen Grace. Vaudeville greats Al Jolson and Eddie Cantor also played the Academy. Seating 1,300, the theater was known as the place where top New York City productions were staged as tryouts before making their Broadway debuts. (Decker collection.)

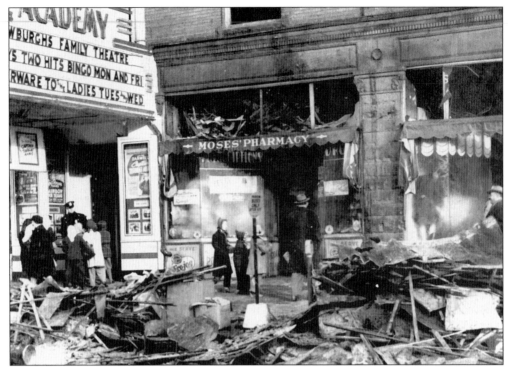

The Academy Theatre became a very popular silent movie house while retaining its live performance schedule and then became exclusively devoted to the talkies. In 1925, a fire caused $25,000 in damages to the theater. This photograph of the 1946 fire, which did $75,000 worth of damage to the building, also destroyed the four stores on ground level. (Collins collection.)

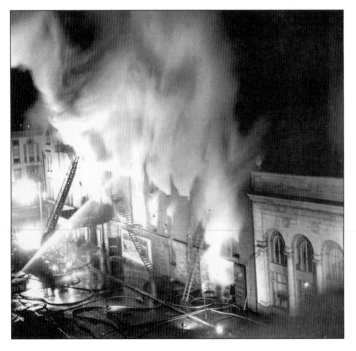

The Academy fire in 1956 was a spectacular blaze that could be seen from miles away. The fire department spent the night at the site, putting out many smaller fires and investigating the source. Remarkably, most of the building remained intact. The front of the building, with the exception of the broken windows, was untainted. (Aiello photograph, Goodbread collection.)

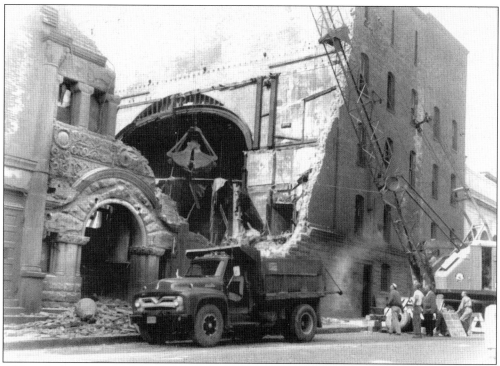

Although the majority of the damage caused by the 1956 fire was confined to the stage area, no one came forward to restore the Academy Theatre. After two years, a bank purchased the building to make way for a parking lot, and the theater was demolished. Newspaper reporter Al Rhodes described this shot as "the charred interior and warped stage gaping nakedly toward the street." (City Records Management Department collection.)

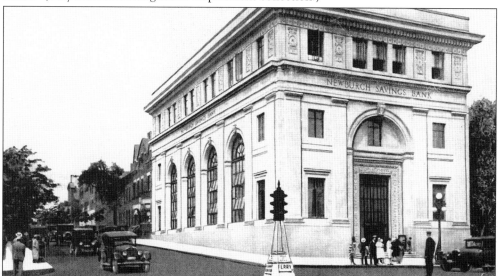

The Newburgh Savings Bank was founded in 1852 and moved to this Broadway location on December 1, 1924. In 1971, the bank held a dinner gala to celebrate reaching assets over $100 million. The public part of the celebration included souvenirs for depositors and a drawing for prizes, with the top prize being a color television. (Decker collection.)

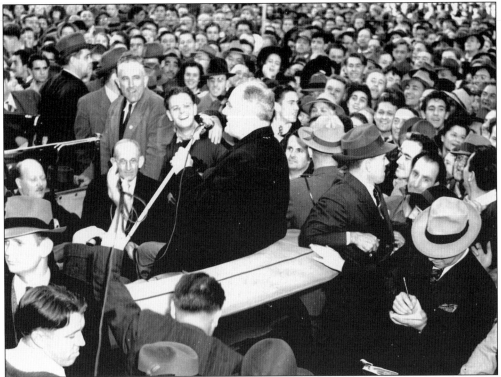

Pres. Franklin Delano Roosevelt speaks to throngs of Newburgh citizens at the corner of Broadway and Liberty Streets at the end of one of his campaigns. Roosevelt considered it good luck to stop in Hudson Valley cities and towns on his way home to Hyde Park to await election returns. (Historical Society of Newburgh Bay and the Highlands collection.)

This 1945 photograph was taken by a real estate agent trying to sell the properties west of city hall to the corner of Liberty and the first two buildings on that street. The total assessment for the properties was $112,300. The asking price for the parcels was $100,000, including six stores and 19 apartments generating $11,000 in income. It was sold in less than two months. (Whitehill collection.)

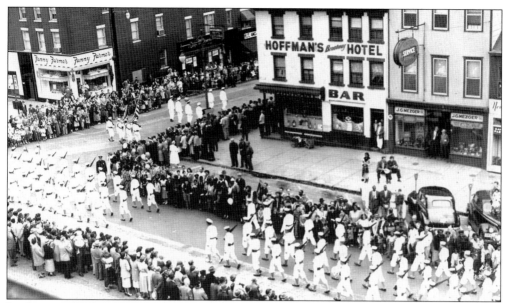

In this parade photograph taken a few years later, the buildings have a new façade and new tenants. Candy store Fanny Farmer remained at the site until 1976. The following year, the building was demolished for a parking lot. On the opposite side of Liberty Street, Hoffman's Hotel, for many years a fixture, and Metzger's, an early automobile electrical store and shop, are seen. (Goodbread collection.)

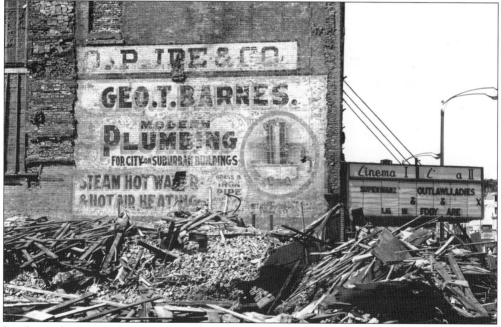

By the early 1980s, the scene had changed. Hoffman's Hotel, having experienced a fire in 1950s, was demolished. When Metzger's, another shop, and the Odd Fellows Hall were razed to make room for another parking lot, an advertisement for George T. Barnes Plumbing was revealed. Barnes had occupied the theater building at the beginning of the 20th century before the other buildings were constructed. (Goodbread collection.)

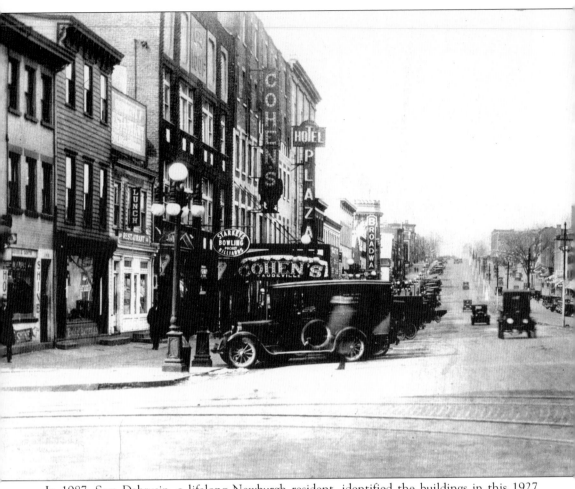

In 1987, Sam Dabrusin, a lifelong Newburgh resident, identified the buildings in this 1927 photograph. On the left are Olympia Shoeshine Parlor; and Metzger's Battery, Chauncey's Lunch, Starkey's Bowling, and Cohen's Opera House and Hotel. On the right, from front to back, are the Alps Restaurant and Bakery, Weed and Bagshaw Hardware Store, a soda shop, a drugstore, and Clark's Restaurant, on the corner of Chambers Street. On the opposite

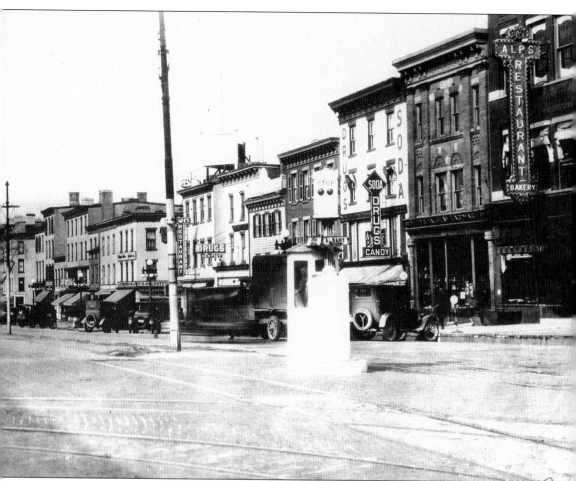

Chambers corner was Goldstein's Men's Shop, followed by Dabrusin's Broadway Market, which had the first freezer facility in Newburgh. Other Newburgh meat firms often took their products to Dabrusin's when they needed them to be frozen and stored. The market's early Buick delivery truck can be seen in front of the store. (Ruben photograph, Historical Society of Newburgh Bay and the Highlands collection.)

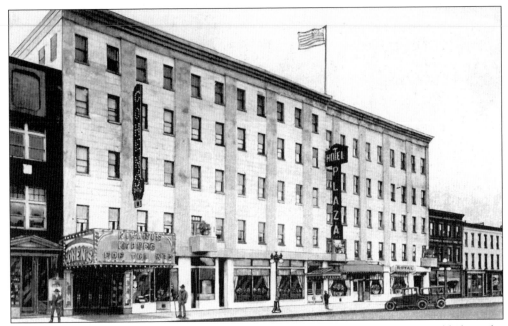

In 1931, Cohen's Opera House became Cohen's Theatre. Two stories were added to the building, and the adjacent wooden structure was incorporated to complete the new hotel and theater. The hotel now had 107 rooms, and the theater not only showed movies but also hosted community groups such as the Kiwanis Club for productions and other functions. (Decker collection.)

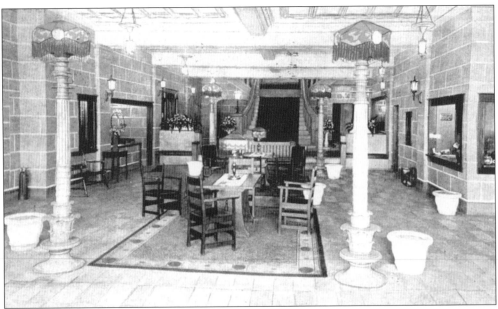

A wide array of styles combined to create the eye-catching interior of the new Plaza lobby. Such opulence during the Depression attests to the significance of the hotel. Within days of its opening, all the rooms in the building were full. This trend continued for almost two decades. (Decker collection.)

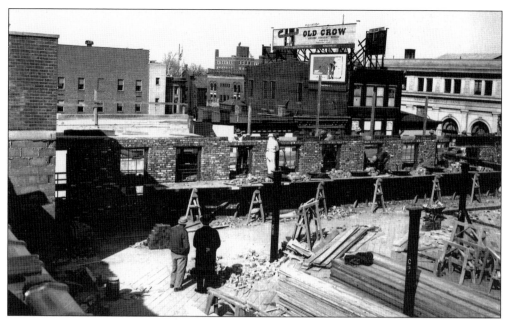

The buildings that made up the hotel theater complex were constructed between the 1880s and the 1920s. In 1941, Joseph A. Fogarty, local engineer and builder, was hired to undertake major reconstruction of the site. One of the changes involved unifying the façade on Broadway so that the building would look like one continuous structure. Above, masons work on brick around the newly installed windows while Joseph Fogarty (in the black hat and coat) looks on. The lower photograph depicts the unfinished front of the 48-foot-high building with bracing. (Flannery collection.)

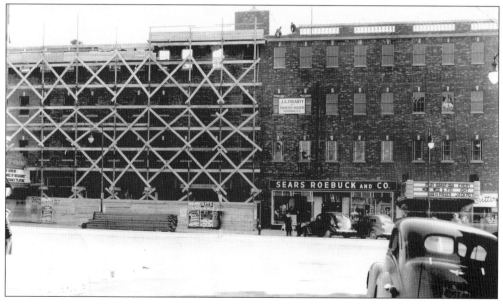

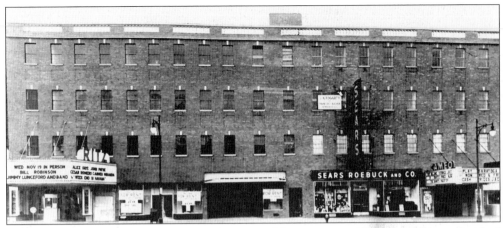

In the lower photograph on the previous page, steel beams jut out of the top of the unfinished last story of the hotel. As part of the work Joseph A. Fogarty did in 1941, a steel frame structure within the building was constructed to give it greater structural integrity. At this time, Cohen's Hotel became the Hotel Newburgh and the Opera House became the Ritz Theatre. (Flannery collection.)

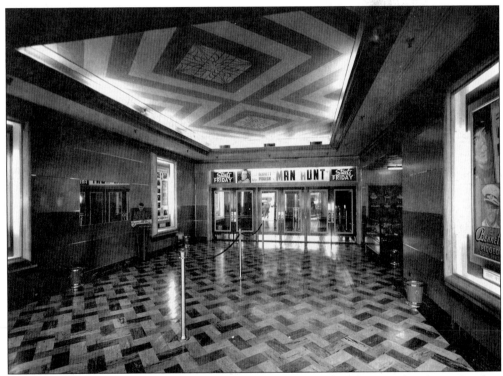

The well-lit, opulent lobby of the Ritz Theatre can be seen in this photograph, taken a few days before the grand opening. The ticket booth is on the left, and the refreshment stand is on the right. Smoking was allowed in theaters at the time, and the cardboard cigarette valet often had sample packs for moviegoers to enjoy during the film. (Flannery collection.)

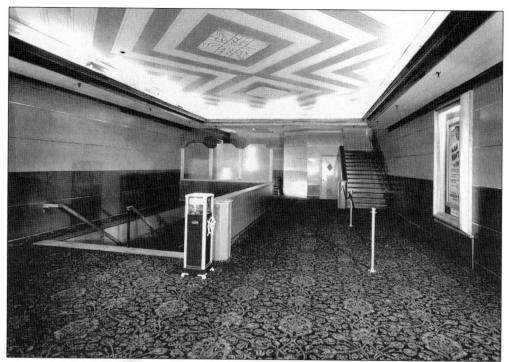

Walking through the doors and into the lobby, the theater patron had a choice to make: go straight ahead and up the stairs to the balcony or down the stairs to the lower level. The ticket taker's station, with its little ship's wheel, can be seen in the center. The first movie to be shown in the newly renovated theater was *Man Hunt*, starring Joan Bennet and Walter Pigeon. (Flannery collection.)

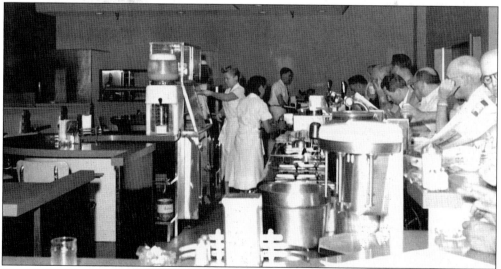

The Coffee Shop was one of the busiest eateries on Broadway. A great place for businessmen and store clerks to have breakfast and lunch, it was the mecca for post-movie snacks or sodas after a Hi-Y dance. In addition to the Coffee Shop, the hotel had a fine dinner and banquet room—the Green Room. Weddings, proms, service organization meetings, and testimonial dinners were some of events held there. (McTamaney photograph and collection.)

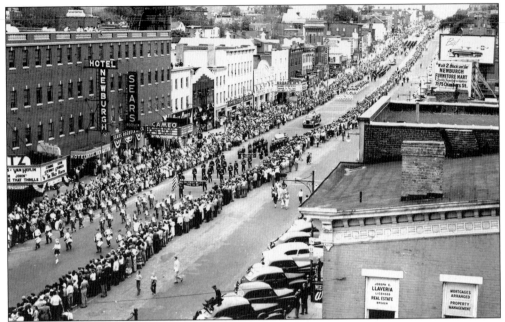

The three movie theaters—the Ritz, the Cameo, and the Broadway—can all be seen in this photograph of the Hudson Valley Firemen's Parade in June 1952. The street is full of people lined four or five deep to see this large parade. This was typical of most parades on Broadway through the mid-1960s. (Aiello photograph, Historical Society of Newburgh Bay and the Highlands collection.)

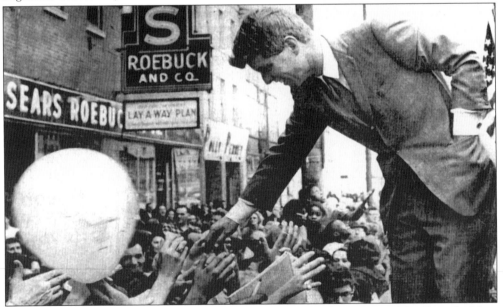

Sen. Robert Kennedy greets a large crowd at a Democratic rally in front of the Sears building in October 1965. That same day, Kennedy also spoke to Newburgh Free Academy students, toured Stewart Air Force Base, and visited Orange County Community College, in Middletown. He was in Orange County to urge all citizens to vote for Pres. Lyndon B. Johnson's reelection and for all local and state Democratic candidates. (Collins collection.)

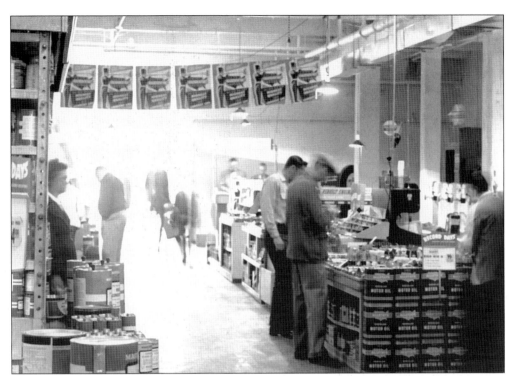

The Sears Automotive and Paint Department was on the ground floor of the building. Access to that part of the store was easiest from Ann Street, in the back. Sears gained additional space for its store by purchasing other property adjacent to it both on Broadway and Ann Street. With the purchase of the Cameo Theatre in the mid-1950s, Sears's size increased significantly. (Goodbread collection.)

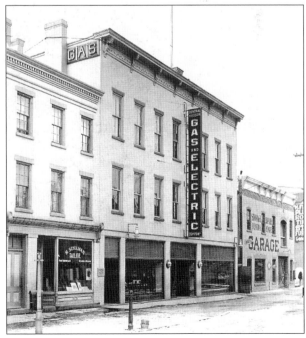

For more than 30 years, Central Hudson Gas and Electric occupied this building at 127–129 Broadway. Begun as the Edison Illuminating Company in 1884, it became Newburgh Power and Light in 1900 and, after acquiring other smaller electric companies in the Hudson Valley in the early part of the century, became Central Hudson. Its stock, a key to its growth, went on sale to the public in 1912. (Historical Society of Newburgh Bay and the Highlands collection.)

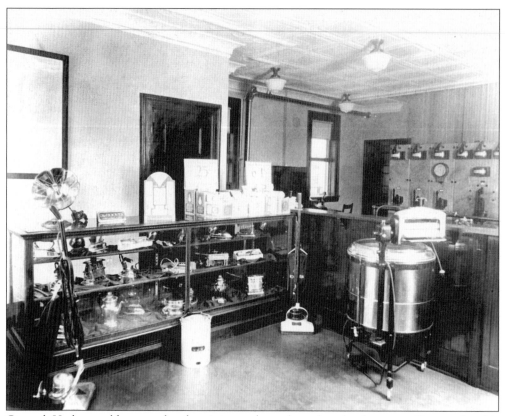

Central Hudson sold not only electricity and gas but also the latest appliances. In this Depression-era photograph, irons, coffee makers, toasters, and vacuums can be seen. Higher-priced items such as refrigerators and washing machines could be purchased outright or on time. In 1935, a refrigerator "could be yours for as little as 25¢ a week." (Goodbread collection.)

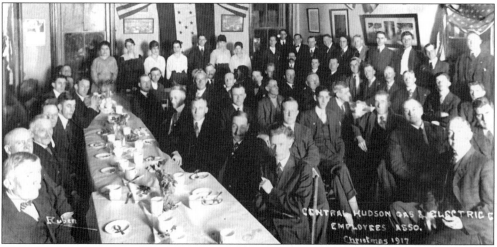

This 1918 Christmas party for Central Hudson employees was held on the second floor of the company's building. The evident patriotism, in the form of flags and bunting, reminds one of the recent end of World War I. Obviously, women were not a large part of the Central Hudson work force then; only six of them stand at the back of the room. (Goodbread collection.)

On January 22, 1943, a fire started in the A & P building and quickly spread to the Broadway Theatre. The heavily varnished bowling alleys above the grocery caused intense heat, and firemen had a difficult time fighting the flames. The theater suffered heavy water damage but was rebuilt. The movie playing that evening was *A Night to Remember*, a harbinger of things to come. (Aiello photograph, Historical Society of Newburgh Bay and the Highlands collection.)

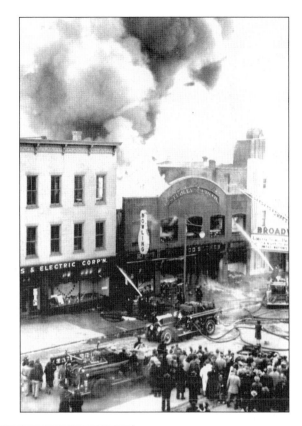

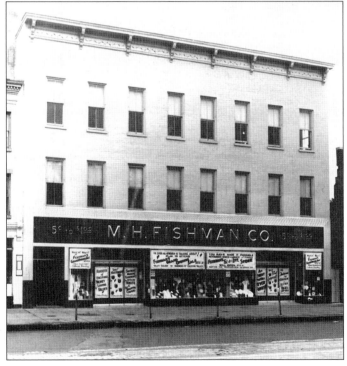

M. H. Fishman and Company opened its new Newburgh store in the former Central Hudson building *c.* 1950. In a 1959 advertisement, Fishman listed a "few good reasons" why smart Newburgh shoppers should come to the store. They included free delivery on purchases over $5, charge accounts, and air-conditioning. (City Records Management Department collection.)

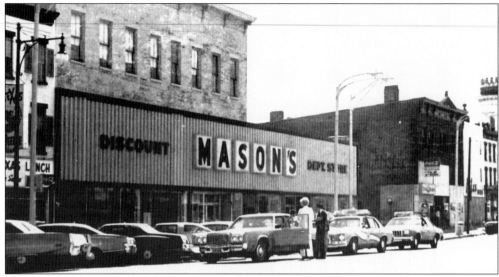

Mason's Discount Department Store replaced Fishman in the late 1960s. Featuring more than 100 departments, the store had a second location in the town of Newburgh. Ben Krieger was general manager of both stores. As more and more stores left the city at this time in search of new facilities and better parking, Mason's struggled to remain. It finally closed in the late 1970s. (City Records Management Department collection.)

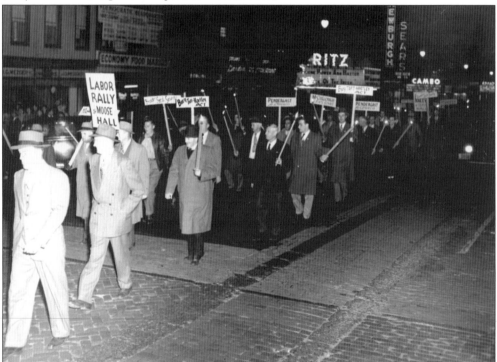

The passage of the Taft-Hartley Act, in 1947, sent shock waves through the ranks of organized labor. Claiming that the act was designed to paralyze and destroy the labor movement, unionists paraded down Broadway on their way to an anti–Taft-Hartley rally at the Moose Hall. (Goodbread collection.)

Two

A MICRO CITY

As in the previous chapter, most of the structures shown here are from the late 19th and early 20th centuries. The majority of them housed smaller establishments and had living quarters above them. Many store owners lived above their shops, but the majority of these buildings held thousands of working-class Newburghers.

These blocks could be called a "micro city" for a good part of the 20th century. One of the best-known complete markets of its time, the Bull Market, was located here. Other grocers, meat and fish sellers, pastry shops and bread stores, and produce sellers provided more necessities of life. Then there were the barbershops, and the men's and women's and children's clothiers, and the shoe stores all within these blocks. Other amenities included jewelry stores, radio and appliance shops, a photograph studio, and Woolworth's and Fishman's Department Stores. For entertainment, there were dance parlors, movie theaters, bowling alleys, a pool hall, and even a fortune-teller at one time. Plenty of taverns and a large variety of restaurants also stood here. Services included at least two doctors, an optometrist and a dentist, a tailor, a cleaner, a real estate agency, and a gasoline station and automobile repair shop. For a while, an undertaker was located next to the gas station. Those in need of spiritual help could always go to the Salvation Army Citadel.

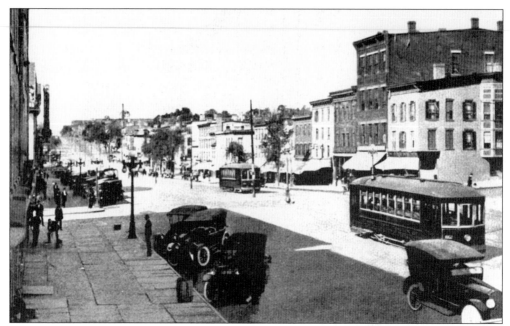

This early-1920s postcard of the north side of Broadway shows, once again, the trolley and cars in competition for space. Benagot Brothers' Cigars, the Alps Restaurant, Weed and Bagshaw Home Furnishings, Aldalyn's Beauty Shop, Gardella Brothers Confectioners, and Delaware Farms Delicatessen were all located on the block. (Jordy collection.)

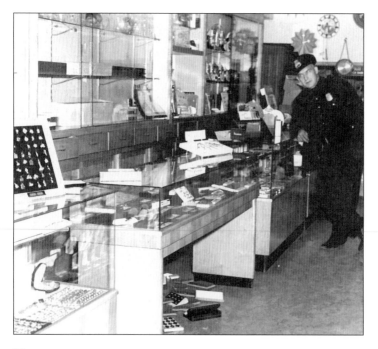

Sometime during the night of November 10 or the early morning hours of November 11, 1959, a thief broke into Nurick's Jewelry Store, then located at 116 Broadway, and stole rings, watches, small radios, and other items valued at more than $9,000. Shown is Lt. Homer Masland surveying the damage. Sgt. J. Murphy and Patrick Cerone investigated the crime. (Newburgh Police Department collection.)

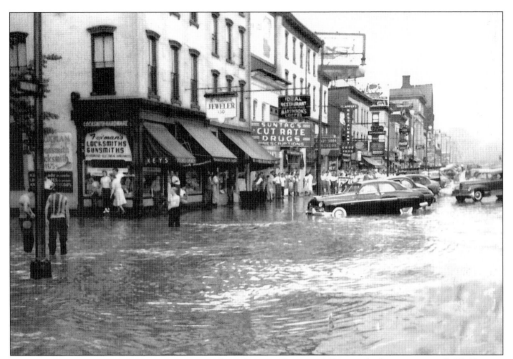

The winter storms of 1948–1949 produced record snowfalls, and the spring of 1949 was extremely wet. This, combined with the problem of clogged storm drains, led to flooding in different parts of the city as summer approached. Here, children play in a small lake created at the corner of Chambers Street. (Goodbread collection.)

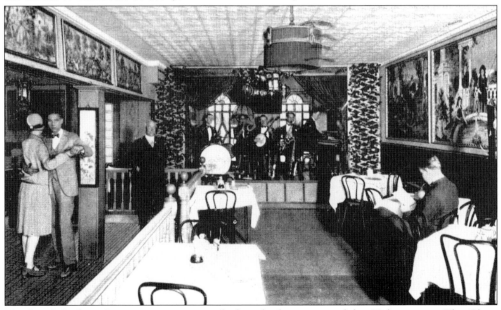

Newburgh had an Asian restaurant even before the beginning of the 20th century. The Chop Suey Restaurant was a very popular one in the 1920s, serving both "American and Chinese dishes at all hours." Located at 124 Broadway, it was open daily from 11:00 a.m. until late in the evening and had music and dancing on most nights. (Cavalari collection.)

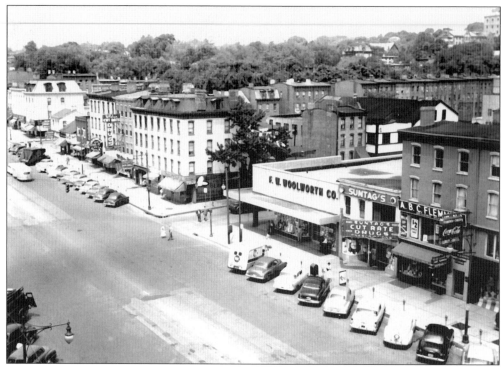

Woolworth's Department Store was very popular in the 1950s and 1960s, offering many items at 5¢ or 10¢. Children could walk from any section of the city and buy something with their nickel or dime allowance. Woolworth's also sold a variety of clothing, and Easter bonnets were a favorite window display. (Aiello photograph, Historical Society of Newburgh Bay and the Highlands collection.)

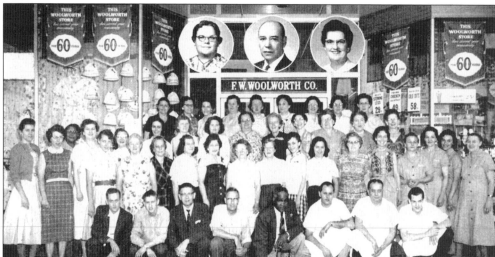

Woolworth's used this photograph during the 1959 celebration in Newburgh. Referring to the store as a "family store where your see your friends and neighbors," it listed long-term employees who lived in the city: Dorothy Mosher, buyer and head floor girl, 32 years; C. F. Hennebuel, manager, 40 years; and Helen Stevens, head cashier, 40 years. (Historical Society of Newburgh Bay and the Highlands collection.)

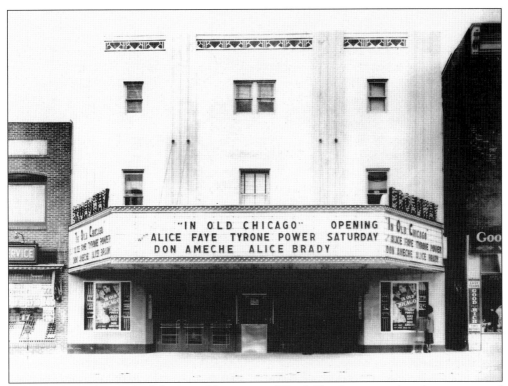

The Broadway Theatre, built by Louis Hanmore and Frank Fletcher, opened its doors to a crowd of more than 2,000 on February 28, 1914. The interior of the building was rebuilt after the 1943 fire (see page 35). Ironically, the film playing the night of that fire was *A Night to Remember,* a film about the *Titanic.* (Historical Society of Newburgh Bay and the Highlands collection.)

Taken by Robert Richards of the *Newburgh News,* this famous photograph of the burning of the Broadway Theatre, on September 1, 1965, appeared in national publications. Unfortunately, the Broadway was beyond help. No one came forward to rebuild the theater this time, and it was demolished to make way for a parking lot that was never built. (Collins collection.)

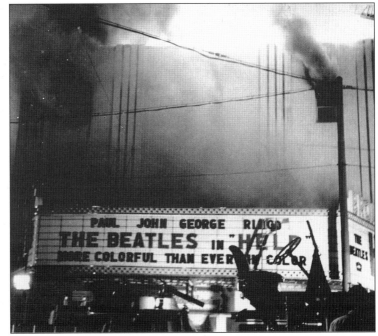

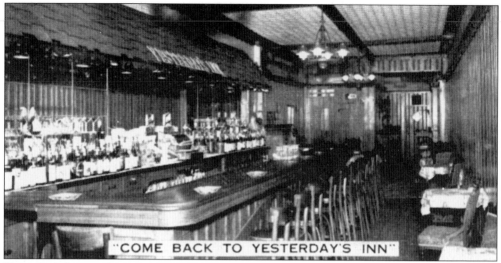

Yesterday's Inn, with its Western décor, was located at 135 Broadway in the late 1950s and early 1960s. In the early part of the century, Henry Fletcher's plumbing business was in this location, followed by Mitsushima Restaurant, the Rivoli Restaurant in the late 1930s, and Schaefer's Radio and Appliances. After Yesterday's, Pat's Texas Hot Weiner's conducted business there from the late 1960s to the 1970s. (Historical Society of Newburgh Bay and the Highlands collection.)

This evening shot was taken in the 1960s from the northern corner of Johnston Street. The stores on the south side, west from Mason's (center, behind pole), were Cowan's Jewelry, Betty Jean's Restaurant, Miles Shoes, Broadway Fabrics, the Hilda Children's Shoppe, and PJ's Restaurant. Wexler's Pharmacy, Roshelle Apparel, OK Shoe Repair, the Broadway Bakery, and Groll's Liquor were on the north side of the block. (Goodbread collection.)

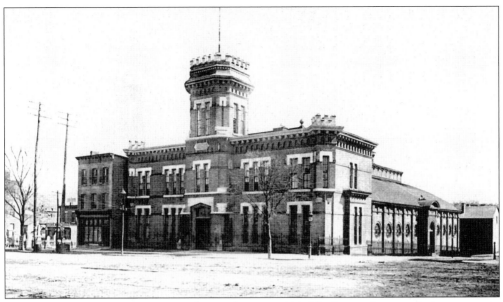

Constructed in 1879, the armory is shown above in 1903. The lower photograph depicts a very important event in Newburgh's history. The United States feared the water supply would be poisoned once the nation declared war. So, two days before the United States entered World War I, on February 5, 1917, with less than 24 hours' notice, Companies E and L of the Newburgh National Guard were called up to guard it. The familiar Newburgh names of Haible, Farina, McCaw, Taylor, Lukacik, Carroll, Fitzpatrick, Kirwan, Mullarkey, Nagle, and Tompkins were among those who left that day. Six inches of snow blanketed the ground, and blizzard conditions prevailed as the men left the armory for the trains taking them to the aqueduct and other parts of the supply. They were the first troops in the country to participate in the war. (Historical Society of Newburgh Bay and the Highlands collection.)

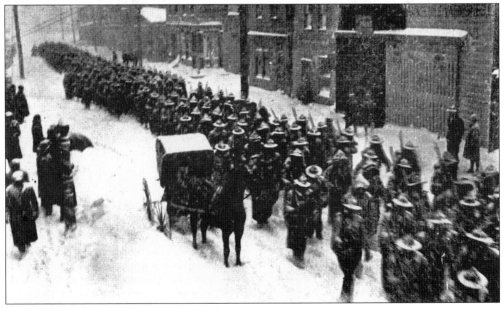

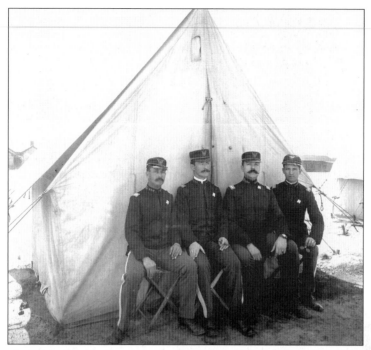

First organized in 1878, the 10th Separate Company, part of the 1st Regiment of the National Guard, was housed for many years in the armory. Capt. William G. Hunter (left) was in command of the company from 1893 to 1906. He is shown with three of his officers while on maneuvers at Camp Higgins in Cape Vincent in 1905. (Historical Society of Newburgh Bay and the Highlands collection.)

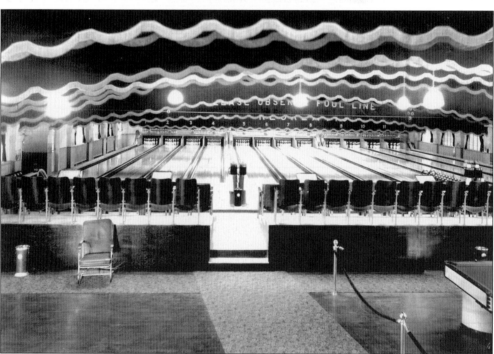

In 1931, a new armory was built and the Broadway armory became home to a number of businesses including the Great Bull Market, the first supermarket located on the bottom floor. The Empire Recreation Center maintained a billiard parlor and bowling alleys, shown here, on the second floor. Owned and operated by the Bontempo family, the center also included a luncheonette. (Valentine collection.)

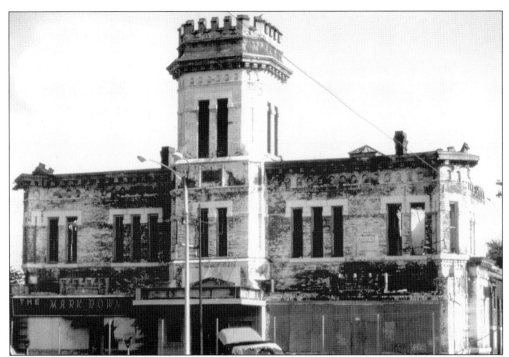

Following many productive years, the armory fell prey to neglect, vandalism, and finally to a devastating fire in 1980. Vacant for more than 15 years, as the above photograph shows in 1989, the building was given new life when the Gemma Development Company undertook rebuilding and renovating the shell in 1997 (below). The 45,000-square-foot building now houses the Orange County Departments of Health, Mental Health, and Social Services and District Attorney's Office. More than 150 people currently work in the building. (Above, Daley photograph and collection; below, Favata photograph and collection.)

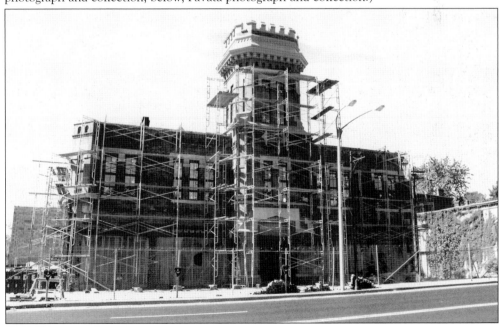

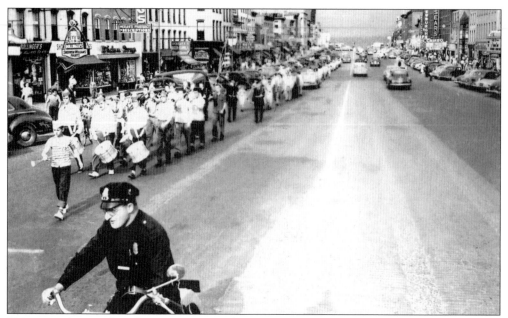

Some parades on Broadway were very short. Officer Patrick Cerone escorts a group of children up the street as traffic continues to travel down the south side. The drivers of cars behind the parade had two choices: they could either wait patiently, inching forward as the participants walked, or take a side street detour. Road rage was not an option in those days. (Goodbread collection.)

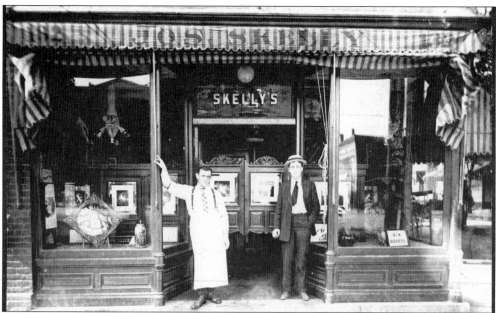

Skelly's Hotel and Saloon was a popular watering hole in the early 20th century. The swinging doors suggest a Western atmosphere, while the German beer stein in the window and the advertisements for Manilla Special Brew and gin rickeys attest to the fact that Skelly's was very cosmopolitan. First located at 132 Broadway, Skelly's later moved to 136 Broadway. (Carlstrom collection.)

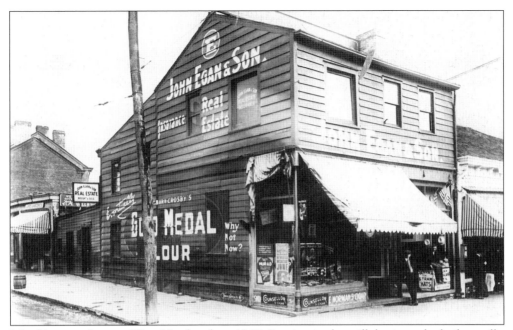

John Egan was born in West Newburgh in 1847. Starting in the milk business, he built a milk-processing plant in the city and sold it when he became interested in real estate. He believed strongly in the development of Broadway and set his primary focus on that end. Buying, improving, and selling many properties on the street, Egan and his son Vincent were very successful businessmen. (Stradar collection.)

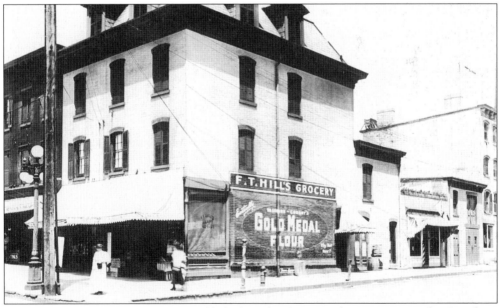

Frederick T. Hills Grocers was an established market for more than 20 years at this Broadway location, on the corner of Johnston Street. It was followed in business by another grocer, Butler, in the 1930s. In the 1940s, the store became Mansfield's Paint and in the late 1940s and early 1950s, Delson's Men's Shop. In 1963, it was home to longtime Newburgh clothier Al Weiss. (Stradar collection.)

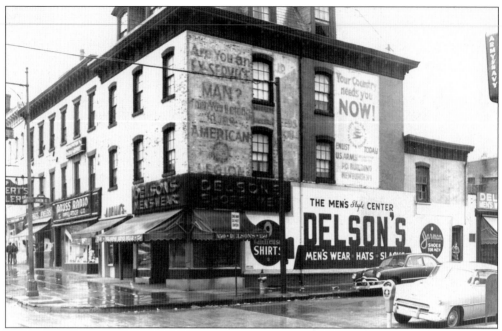

Delson's was one of the many fine men's stores on Broadway. The shop sold everything from Adam-Long hats to Gantner swimwear. Owner Sam Delson was murdered in his own store in the 1950s. It is believed that he surprised a burglar and was killed as he tried to resist him. The murder is still unsolved. (Goodbread collection.)

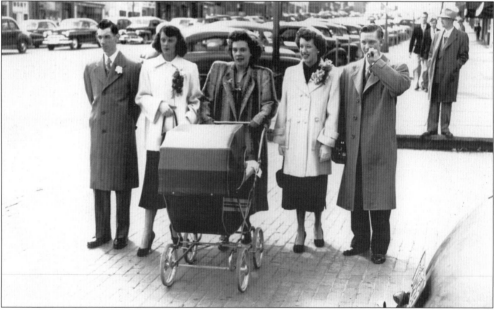

At Easter, Broadway was Newburgh's Fifth Avenue. In this 1949 photograph, Lucy Lynch (center) pushes her first child, Peggy, in the baby carriage, down Broadway. With her are, from left to right, her husband, Bill, and friends Peggy McDonough and Margie and Hugh Weiss. Mother's Day was another occasion when people would dress in their finest clothes and parade down the street. (Goodbread collection.)

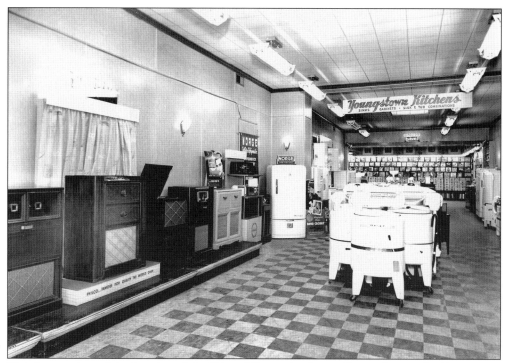

This is a portion of the interior of the Edward Rouss Appliance Store. During the Depression, Rouss rented refrigerators at the rate of 25¢ a week to families who would drop their quarters into a coin box on the side of the unit. Every few months, the appliance store would collect the coins, and at the end of a predetermined period of time, the family would own the refrigerator. (Whitehill collection.)

The Wright Meat Market, located at 160 Broadway, was the fourth location for a Wright family meat market. George Wright made the famous Wright's sausage; the youngest, Greg "Butch" Wright, delivered most of the orders. The Wrights wrote and calculated each order by hand. Printed on their bills was the statement that "all accounts must be settled by the end of the week." The store was closed after Jim Wright died in 1957. (Stradar collection.)

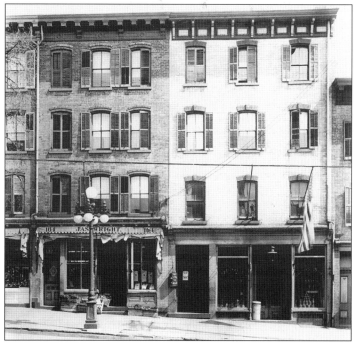

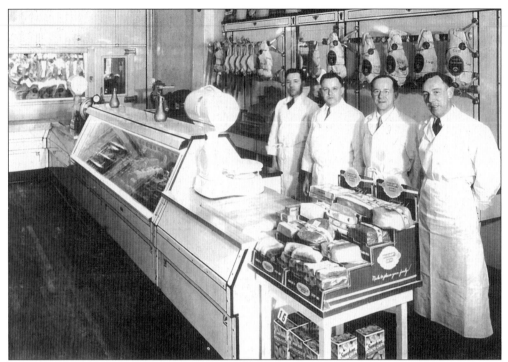

Pictured here are the Wright brothers, from left to right, Butch, John, Jim, and George. Mary Jane Miller, Butch Wright's daughter, still remembers her father making deliveries to a woman named Mrs. Creeper, who lived above a local funeral home. During the war years, Mrs. Creeper would give the father candy bars and gum for Mary Jane and her brother—a real treat for the children. (Historical Society of Newburgh Bay and the Highlands collection.)

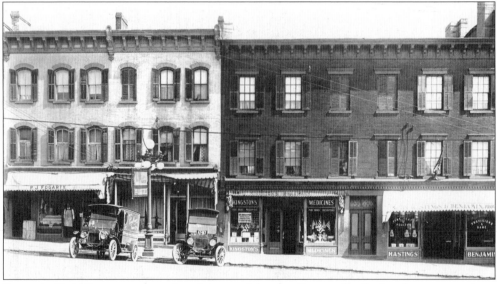

Fogarty's Shoe Store was owned and operated by the Fogarty family for three generations. Founded by Patrick Fogarty, his son James and grandsons James and Patrick eventually took over the business. A true family shoe store, it offered the best quality men's, women's, and children's footwear. (Stradar collection.)

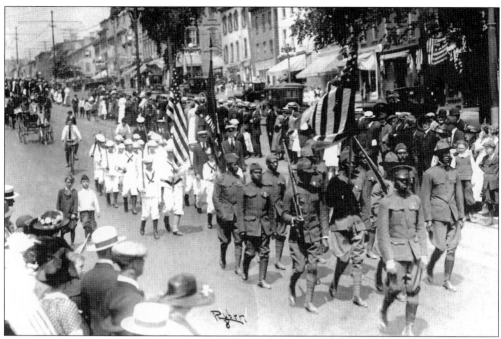

Veterans of World War I march down Broadway past DuBois Street in the 1920 Memorial Day Parade. This unit was most likely a part of Hamilton Fish's famed 369th, which remained on the front lines for 191 days straight. The men are followed by a group of boys in naval uniforms who, according to Herbert Johanson, were associated with the Grace Methodist Church. (Historical Society of Newburgh Bay and the Highlands collection.)

Johnson's Meat Market is shown on the northwest corner of Broadway at DuBois in this 1917 assessment photograph. Frank Ross was the barber next-door, with the square barber pole, and next to the east was David Sheenan's Fish and Oysters Market. By 1924, some of the players had changed: Frank Zelie owned the meat market, and Ralph Selito owned the barbershop, but Sheenan still operated the fish market. (Stradar collection.)

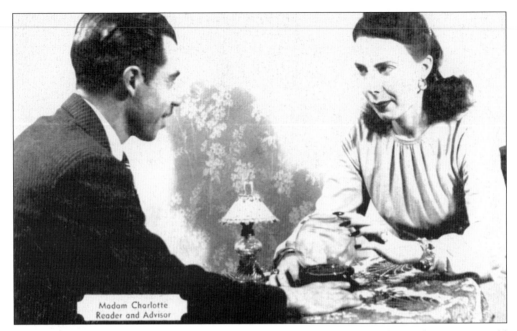

Madam Charlotte
Reader and Advisor

Madam Charlotte had a fortune-telling business on the second floor of where Johnson once sold meat and poultry. Her advertisement stated that she was a "gifted reader and advisor" and offered "advice on all matters such as love, marriage, courtship, health, and business. Satisfaction was assured." She apparently was located at that site for only a short time, and no records exist of her successes or failures. (Jordy collection.)

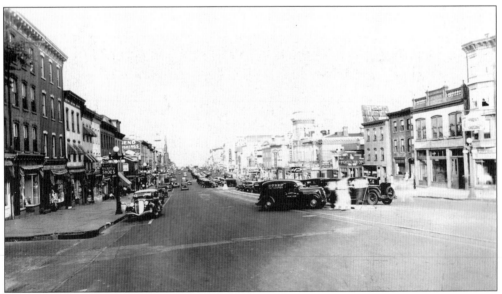

During the early 1930s, an experiment was done on Broadway in an attempt to alleviate parking problems. The city council decided that the street was wide enough to allow two rows of diagonal parking in the center and parallel parking on both curbs. The scheme proved a dismal failure, and the original parking plan was reinstated. George Mason's Garage appears to the far right with the fancy balustrade. (Goodbread collection.)

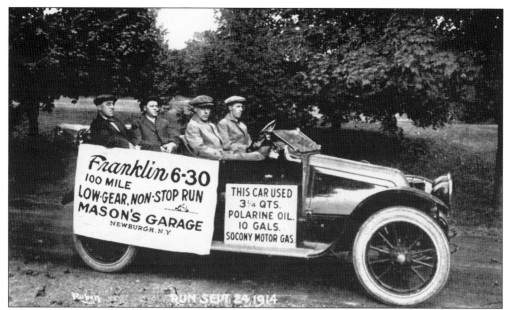

On September, 24, 1914, Mason's Garage sponsored a 100-mile test drive through the towns and hamlets of Orange County, using only low gear. The Franklin left Newburgh at 8:23 a.m. and returned at 5:19 p.m. The team was pleased to report that the automobile had used only 10 gallons of Socony gasoline and 3.5 quarts of Polarine oil, two items sold at Mason's. (Whitehill collection.)

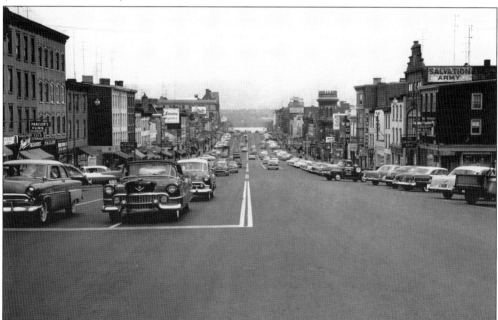

A Ford (left) and a 1957 Cadillac, with a Chevrolet behind it, wait for the light to turn green at the Dubois Street intersection. In this wide-angle shot, both sides of the street can be seen. On the north side, some of the stores were Flo-Clair Dress, Tienken Surgical, Cornell's Jewelers, and Pariser's Furs. On the south side, the WGNY radio station building and the Salvation Army Citadel are visible. (Historical Society of Newburgh Bay and the Highlands collection.)

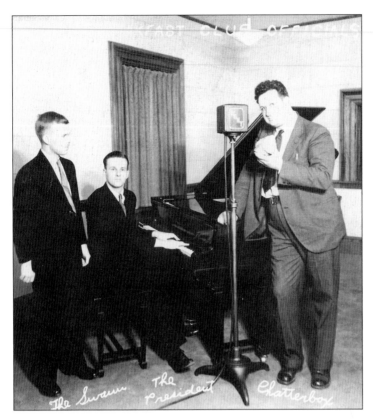

During the 1940s and 1950s, the WGNY radio station occupied part of the former Mason's Garage. According to Rev. Campbell K. Thompson, who worked at the station for many years, this photograph of the Breakfast Club preceded his coming to the station in 1947. The Chatterbox (right) was Joe Rake, but the identities of the other two men remain a mystery. (Whitehill collection.)

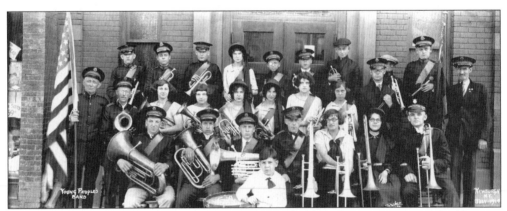

The Salvation Army came to Newburgh in 1884. It held its first meetings in a building on Broadway that is no longer standing. By 1910, the corps was looking for a site to build a citadel that would hold its expanding membership. Within a few years, the new citadel was built, and the Salvation Army stayed at that location until 1983, when it moved to Van Ness Street. Here, members of an early band pose with their instruments in front of the Salvation Army Citadel. (Whitehill collection.)

In this parade photograph, the sign for General Photo Supply can be seen on the right. Frank Mancinelli, owner of the photography shop, ran a special for the opening of the Newburgh-Beacon Bridge in 1963. Offering the "most advanced camera system in the world," the Polaroid special automatic 100 color pack could be purchased for only $139.95. Using this system, one could instantly commemorate the new bridge over the Hudson River. (Goodbread collection.)

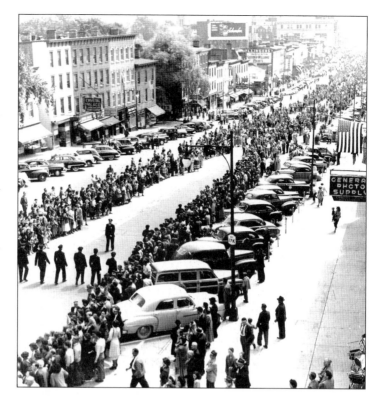

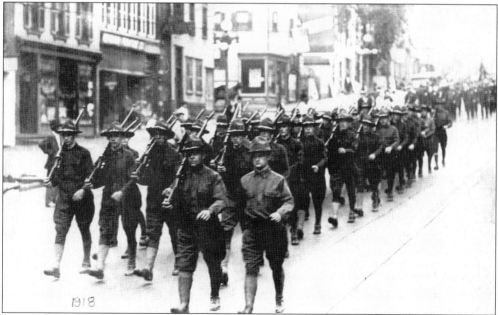

This photograph does not depict a parade. It shows men marching down Broadway in 1918, heading for the troop trains on the waterfront that would take them to ships bound for Europe and the war. The first soldier in the second row is Chester "Chet" Lyons, who lived on upper Broadway and came back safely to Newburgh at the end of the war and worked as an engineer. (Hansen collection.)

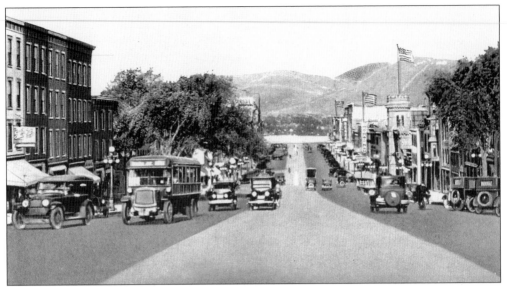

This photograph was taken shortly after the removal of the trolley tracks and their repaving. The tracks ran down the middle of the street, and the repaving, because of material used, gave Broadway a striped effect. The white pillars in the center are early traffic lights. Police were often used to regulate the traffic on the street, as the lights were small, hard to see, and often not synchronized or working. Eventually they were replaced. (Decker collection.)

The Newburgh Police Department and the Newburgh Jaycees sponsored a Grand Prix Soapbox Derby in 1976 on Broadway as part of Newburgh's bicentennial events. Winners pose with Jaycee volunteer Stewart Glenn (center, in the white shirt) and Det. Anthony Costa (in the dark suit and dark glasses). In the back left, Dee Carleton holds a young child, and teacher and local minister Ronald Truncali is pictured next to her. (City Records Management Department collection.)

Three

ON THE CREST
OF THE HILL

This chapter begins with a look back on Broadway toward the river from the crest of the elevation above William Street. The majesty of the mountains, the view of the Hudson, and the width of the street are just some of the reasons for its designation as a perfect parade thoroughfare. More celebrations and parades are viewed in this chapter; one of the parades is disturbing, but as part of the street's and Newburgh's history, it cannot be ignored.

Long-term enterprises such as Stewart's Buick Garage and newcomers to the business community such as Dave Stewart's Electrical Equipment Store are seen. Also pictured are some establishments that moved from lower to upper Broadway during the 1940s and 1950s.

Photographs exist of the first major factory to be built on this stretch of Broadway, as well as its later demise. Pictured also is the first school, which served as an elementary school for many years and then became part of a college system. Some of the students who attended are profiled. Images of buildings that have been adaptively reused, like the firehouse, are included. Peace parades at the end of World War I show the resolve of Newburgh citizens during another era. The first in-town motel and the only cemetery on the street are also pictured. Future president John F. Kennedy appears on his famous walk on Broadway with Mayor William Ryan.

Also included is Cy's Diner, hotbed of political and business activities, with one of its longtime employees. These blocks were very active during the later part of the 20th century.

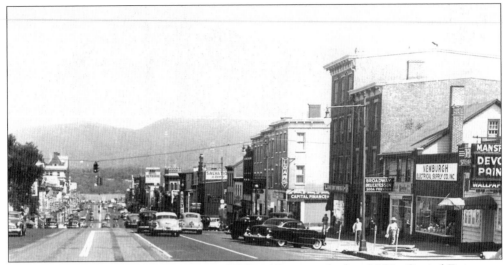

Traffic flows past the busy intersection at William Street in the late-1950s. Capital Finance, a loan company managed by Fred Ball, appears on the southeast corner. On the other side of the street stands Orange County Importing, followed by the Broadway Deli operated by Robert Siminson and the Newburgh Electrical Supply Company. The well-known Hofbrau Restaurant is hidden by the Mansfield Paint sign. Mansfield's was located on Broadway for 40 years. (Goodbread collection.)

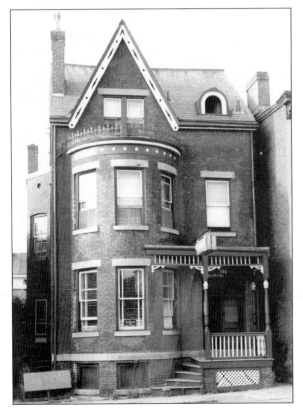

Real estate broker S. Jeffrey Starin bought the former Mansfield tourist home, at 205 Broadway, in the late 1950s to serve as his office (note the small sign in window). Known as "Starin the Baron," he painted this charming building to resemble a castle fit for royalty. He remained at this location for 20 years. (Starin collection.)

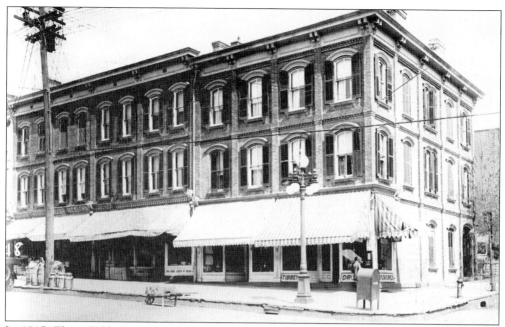

In 1917, Elmer Tibbitts graduated from the Albany College of Pharmacy. He first worked in Newburgh as a pharmacist for the Fred Wallace Pharmacy on Grand Street but, after a year, purchased this building from John and Thomas Buckmaster to open his own drugstore, which he called the Red Cross Pharmacy. Next-door was Basso's Confectionery Store, which made its own ice cream—the reason for the numerous milk cans seen on the curb. (Stradar collection.)

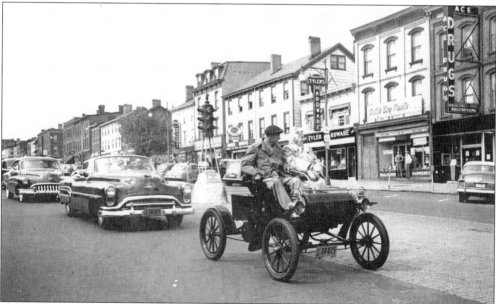

In this 1950s car parade photograph, Tibbitts's drugstore is now Ace Drugs, and Basso's Confectionery Store is the home of the Collins and Adams Paint Store. Ingram Stubley drives the antique car at the front of parade. Stubley, a local florist, had a collection of antique cars that he drove on such occasions. Behind him are a vintage Oldsmobile and Buick, probably the newest cars in the parade at the time. (McTamaney photograph and collection.)

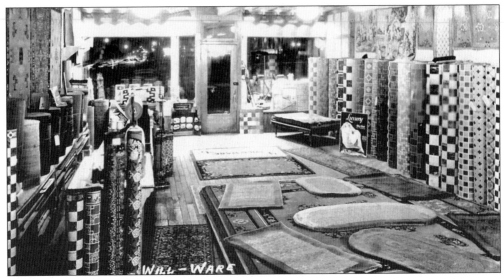

Rolls of linoleum and rugs cover the interior of Will Ware's store in the 1930s. Ware, whose specialty was "permanent linoleum floors," had three different locations on Broadway in the 20th century. Starting at 206 Broadway in 1925, he moved to 192 in the 1930s and then to Water Street and back to Broadway at 59–61 from 1942 through 1972. (Historical Society of Newburgh Bay and the Highlands collection.)

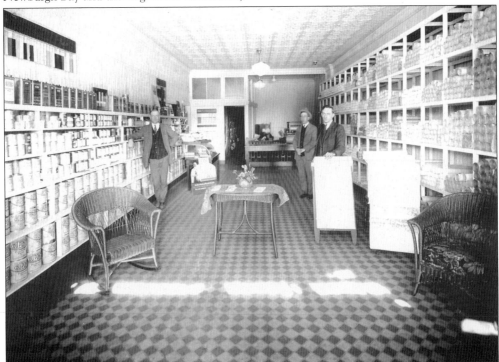

Frank Collins and Harry Adams opened their paint and wallpaper store in 1924 at 194 Broadway and remained there for more than 40 years. Carrying a "full line" of wallpaper (the neatly stacked rows on the right wall) and a "complete line of exterior and interior paints by Dutch Boy and DuPont," the owners prided themselves on quality service. (Collins collection.)

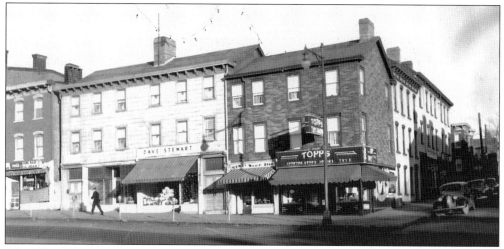

After World War II, Dave Stewart opened an electrical equipment store on the north side of Broadway between City Terrace and Lutheran Street. West of his store were Johnson's Beauty Shop, G. C. Moustakis' Confectionery, Timiani's Barber Shop, and Benagot's Hat Cleaners. In 1953, Stewart moved to 70 Broadway and began to sell appliances. (Goodbread collection.)

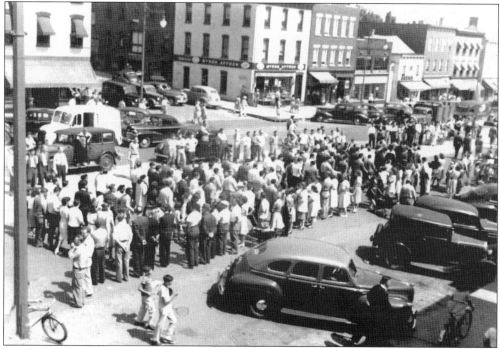

This photograph, taken some 20 years before the one above, shows a small parade marching down Broadway past Carpenter Avenue. Some of the buildings visible on the north side are Affron's Motorcycle Store, on the corner, New Systems Plumbing Supply, and Mastrota's Shoe Repair. West, on the other side of Carpenter, stood Harvey's ("Bud's") Tire Store and the Kalamazoo Stove and Furnace Company. (Stewart photograph, Historical Society of Newburgh Bay and the Highlands collection.)

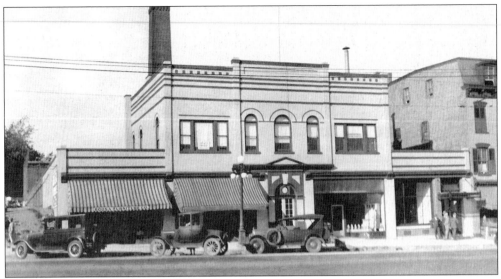

Originally the Orange County Traction Company's maintenance and storage garage for its trolleys, this building was purchased and remodeled by the Roosa Furniture Company for one of its furniture showrooms. The company rented the right wing of the structure to Highland Quassaick National Bank and Trust for a branch office. (Stewart photograph, Historical Society of Newburgh Bay and the Highlands collection.)

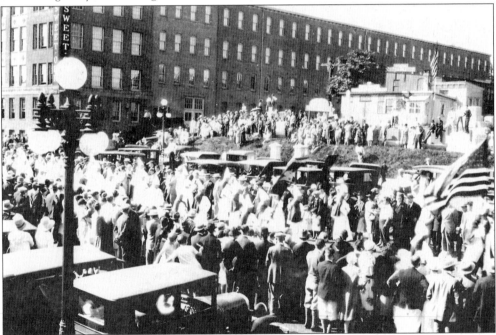

Not all parades were positive in nature. After a rally on the Industrial Tract, Ku Klux Klan members from as far away as Long Island marched down Broadway on Labor Day in 1924. Newburgh's American Legion Band had refused to participate in the parade, so a Beacon band and drum corps hired by the Klan provided marching music. Heralded as a parade of 8,000, the parade actually had fewer than 560 participants and lasted less than eight minutes. (Stewart photograph, Historical Society of Newburgh Bay and the Highlands collection.)

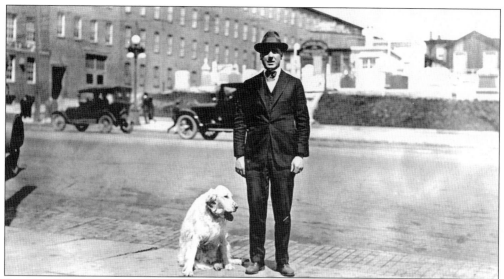

Otto Brown and his dog Jesse pose in front of the Broadway Garage. Brown was Thomas Wesley Stewart's bookkeeper when Stewart owned the Brookside Ice Company. Stewart made Brown a one-third partner of the Broadway Garage in 1921 and made his son Thomas "Archie" Stewart a one-third partner in 1923. In the late 1960s, Arthur Murray, a lifetime employee and an African American, became a partner in the business. (Stewart photograph, Historical Society of Newburgh Bay and the Highlands collection.)

After more than two decades on lower Broadway, the Central Hudson Gas and Electric Company built this impressive brick and granite structure on the corner of Concord Street soon after World War II had ended. The company vacated the building in the 1970s, and it did not have a tenant until Steinberger Guitar Maker came to Newburgh in July 1982. La Bella Strings then followed at the location. (Aiello photograph, Historical Society of Newburgh Bay and the Highlands collection.)

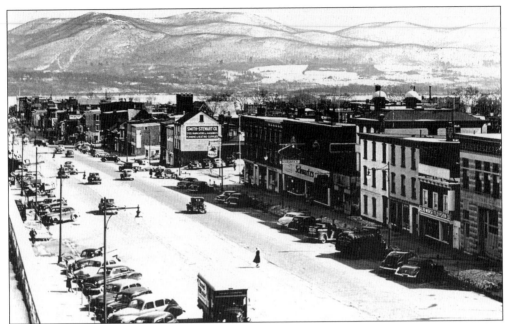

Looking at the opposite side of the street from the roof of Central Hudson in the 1940s, this view shows the Smith-Stewart Company, steel fabricators, machinists, and plumbers; the Mobil gas station; Schwartz's Tire Company; and the Morse Television Company. In the 1950s, Schwartz's enlarged its building and began selling toys, games, appliances, and housewares. The company also sold phonographs and records. In 1963, monophonic albums sold for $2.45, and stereo for $3.10. (Historical Society of Newburgh Bay and the Highlands collection.)

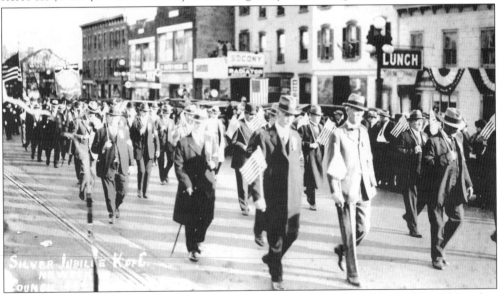

Newburgh Council No. 444 of the Knights of Columbus organized in September 1899 with a membership of 84 men. In 1924, the group held a parade in conjunction with its Silver Jubilee. The Knights held their meetings in the original City Club building, on Third Street, for many years until the building was demolished by the Urban Renewal Agency in the late 1960s. (Cracolici collection.)

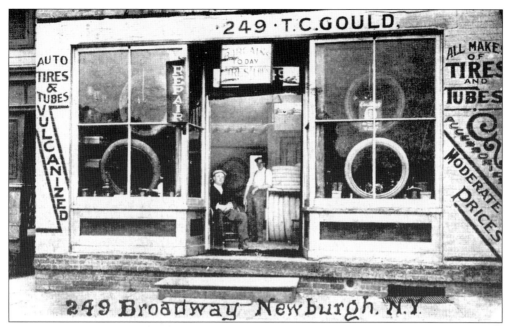

In this building, at 249 Broadway, Thomas C. Gould opened a tire store in the early years of the 20th century. He advertised both bargain-priced and moderately priced tires, from $15.50 for a 28- by 3-inch to $22.50 for a 32- by 3.5-inch. Tubes ranged from $4.35 to $6.75. At these prices in 1910, it is no wonder Gould also included in all of his advertising "Repairing our Specialty." The building was removed long ago. (Whitehill collection.)

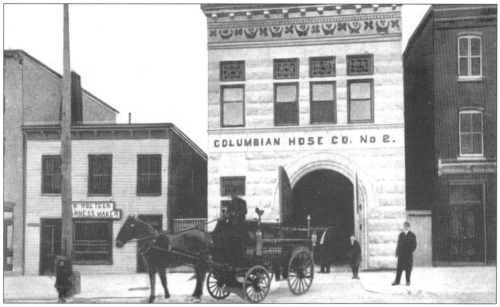

Columbia Hose Company No. 2 was erected in 1905, after upper Broadway employers such as Sweet Orr, the Orange County Traction Company, Crawshaw Carpets, and Stroock petitioned the city council for fire protection. The hose wagon was built in 1905 by Newburgh's Delancy and Covill and was driven by Charles Whitehead. (Historical Society of Newburgh Bay and the Highlands collection.)

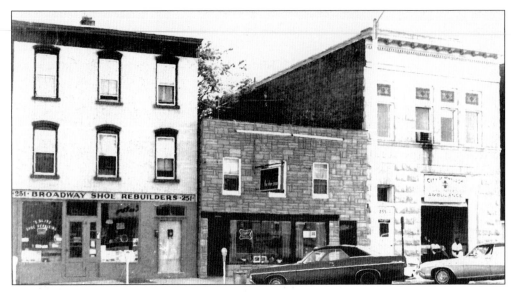

Some 60 years later, the firehouse became the home of the Newburgh Volunteer Ambulance Corps. Michael Holtgen's harness-makers shop, to the left, was given a new Permastone façade and was operated as a bar and restaurant. In 1969, the building and business was offered for sale at $15,000. (City Records Management Department collection.)

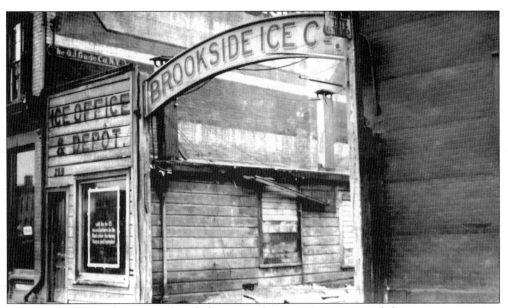

The Brookside Ice Company, founded on March 1, 1902, was one of the many enterprises operated by the Thomas Wesley Stewart family. Harvesting ice from ponds on the family-owned farm on the Cocheton Turnpike, the company advertised "pure ice." Housewives would put a yellow card in their windows to signal a need for ice. Brookside responded by delivering ice to their homes in a yellow truck. (Stewart photograph, Historical Society of Newburgh Bay and the Highlands collection.)

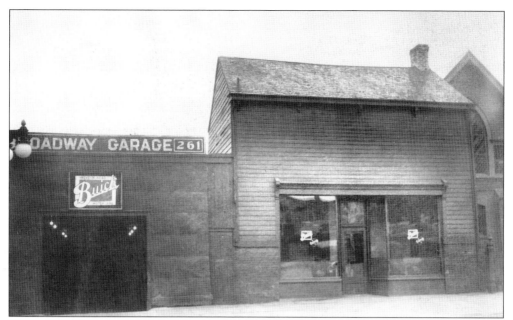

The original Broadway Garage was a wooden structure when Thomas Wesley Stewart started selling used cars in 1909. Stewart then became a dealer for Pierce Arrow and Autocar. In 1912, he added Buick to the lineup. During World War I, he sold the Brookside Ice Company and, in 1927, built a new masonry showroom. Broadway Garage was one of the earliest Buick dealerships in the United States. (Stewart photograph, Historical Society of Newburgh Bay and the Highlands collection.)

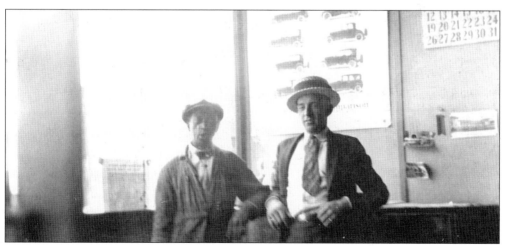

A mechanic (left) and a Buick salesman pose beneath a poster advertising the new Buick models in the 1920s. The owners of the garage (the Stewarts and Otto Brown) were very proud of the fact that during the Depression, through skillful management of the company, not a single employee was laid off. (Stewart photograph, Historical Society of Newburgh Bay and the Highlands collection.)

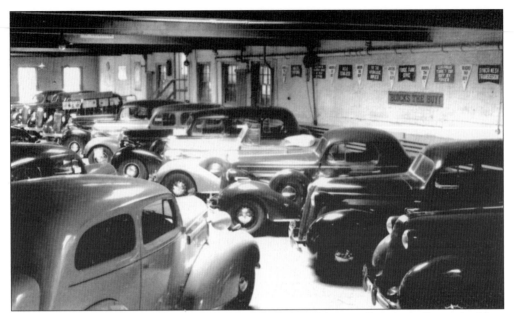

Gleaming new automobiles wait for buyers in the garage of the new Broadway Garage building in the 1930s. So it was for another 50 years until 1988, when the dealership moved. At the time of sale, the Broadway Garage was the oldest operating Buick dealership in the United States that had existed under one continuous ownership. (Stewart photograph, Historical Society of Newburgh Bay and the Highlands collection.)

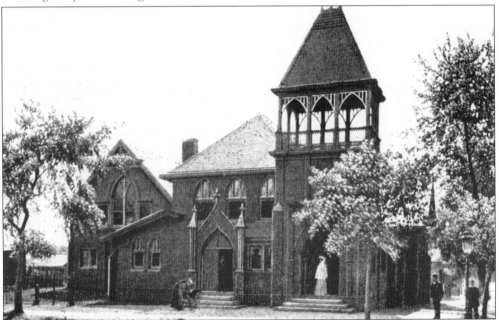

Started as the mission church of St. George's Episcopal Church in 1873, the current Good Shepherd was completed in 1890 and consecrated in 1891. When the church first opened its doors, the surrounding area to the west was considered very unsafe and "ungodly." Newspaper accounts of the time speak of the mill workers who lived in the area as "brawling thugs" who needed "saving." (Whitehill collection.)

68

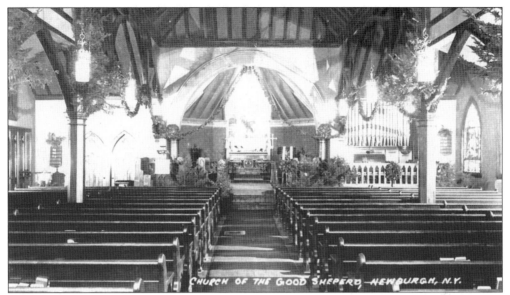

This 1930s photograph shows the interior of the church. The pews are constructed of oak, and the interior woodwork is North Carolina pine finished in a creosote stain resembling walnut. The walls are sand-finished in white. Lamb and Company of New York City created the Good Shepherd window in the sanctuary at a cost of $350. An alcove on the west of the chancel houses an organ donated by Joseph Chadwick. (Historical Society of Newburgh Bay and the Highlands collection.)

In 1927, the original wooden tower of the church was replaced. Good Shepherd Church sent 250 of its men to the front in World War I, an incredible number from a mission church with a medium-sized population. The new masonry tower was built in honor of the congregation's sacrifices in the war. It had a perpetual light that kept the tower lit in honor of the 15 members who lost their lives in the conflict. Efforts have been under way for some time to restore it. (Historical Society of Newburgh Bay and the Highlands collection.)

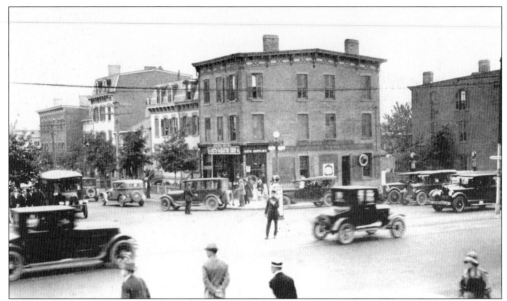

Dressed in their Sunday best, people head in many directions to go to or return from the many churches in the city. These images may be from Easter Sunday in 1926 or 1927. Above, one well-dressed group stands on the corner in front of the Church of the Good Shepherd; some appear ready to board the bus. A policeman stands in the center of Mill Street, directing cars making a right-hand turn off Broadway. Some of these people are likely headed for the Italian Reformed Church, whose upper facade can be seen in the upper right. The difficulty of the traffic patrolman's job is showcased in the lower photograph. Wedged in, the patrolman stands directly in the path of the automobiles, refraining from using his whistle in an attempt to help people cross the street. (Stewart photographs, Historical Society of Newburgh Bay and the Highlands collection.)

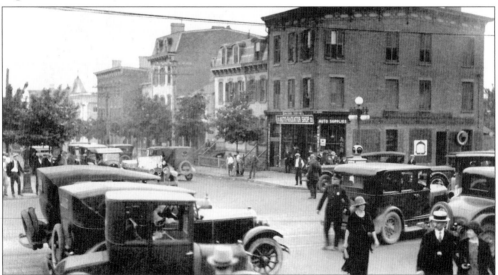

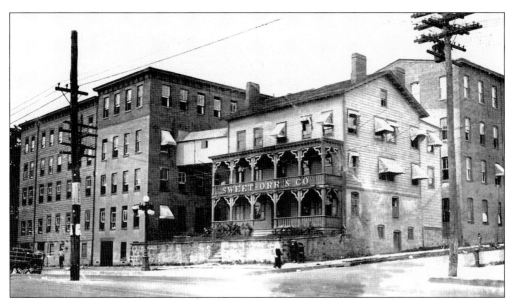

Sweet Orr's main headquarters, at the corner of Concord Street, is a collection of buildings in this *c.* 1900 photograph. At that time, the offices on the right were connected to the factory on the left and in the back by elevated walkways. In 1919, these buildings were replaced by a modern factory and office complex that remained in use for more than 50 years. (Decker collection.)

One of the "Sweet-Orr girls" models a "woven not printed cloth in pure indigo blue" pair of overalls in this advertising postcard. During and after World War I, Sweet Orr used many attractive women to advertise its strong but fashionable line of women's work clothes. It was the first time a United States company promoted women wearing pants. (Jordy collection.)

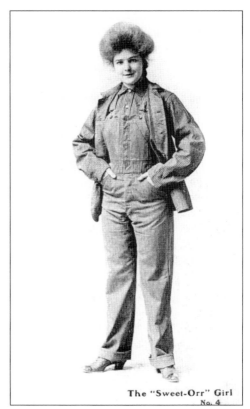

The "Sweet-Orr" Girl
No. 4

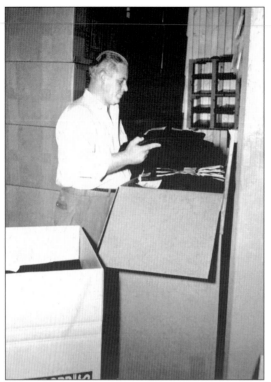

In 1956, Sweet Orr's 75-year history with Newburgh ended when the company moved south and put its building up for sale. Strikes and other labor disputes had crippled its northern ventures. This was unfortunate since Sweet Orr had one of the first organized garment unions in the country. Here, longtime employee Oliver Oakes packs a shipment of clothing to be sent to a retailer during the last few days the factory was in operation. (Aiello photograph, Historical Society of Newburgh Bay and the Highlands collection.)

Eventually, seven small local businesses took up residence in the former plant. Among them were VSD Clothing; Christina Blouses; Newburgh Bag; Gerald Luggage; Dawn Enterprises, handbag manufacturer; Philda Manufacturing, dress company; and Hudson Valley Print, silkscreen concern. Combined, these businesses employed more than 300 people. (Aiello photograph, Historical Society of Newburgh Bay and the Highlands collection.)

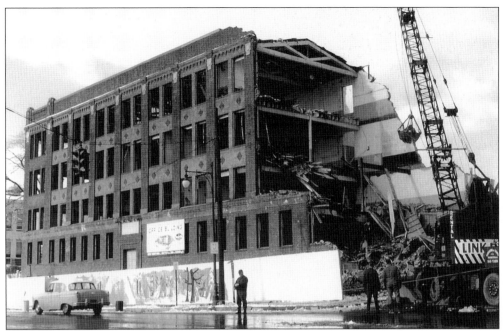

When the Sweet Orr building was sold and finally demolished in 1966, the cornerstone was opened. It revealed, among other items, a 1918 penny; an August 21, 1919, edition of the *Newburgh Daily News*; a 1919 Sweet Orr price guide; and a photograph of Roland Bassett, known as Sweet Orr's "Flying Salesman," and his vintage seaplane arriving in Newburgh Bay. (Daley photograph and collection.)

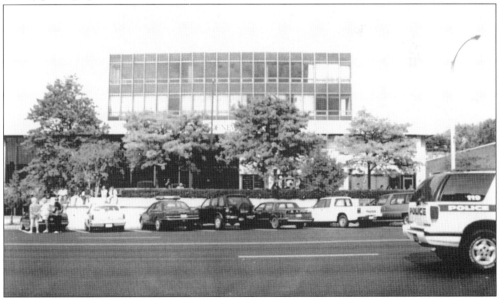

County National Bank erected its new headquarters and office complex on the Sweet Orr site in 1967. William Cann, architect for the project, believed it would be a bank for at least 50 years. In designing it, he "visualized change in our lives, maybe in 20 years, that included automation and a checkless society with electronic transactions," according to the grand opening brochure. (Linton photograph, Goodbread collection.)

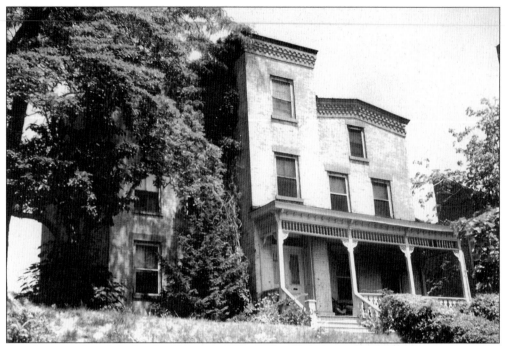

Another casualty of the bank office complex was the Gearn homestead, built in 1850. Helen V. Gearn, former junior high school art teacher and longtime city historian, and her sister Sarah were the last occupants of the 14-room house. The Gearn family operated an oilcloth factory for many years at First and Concord Streets. (Daley photograph and collection.)

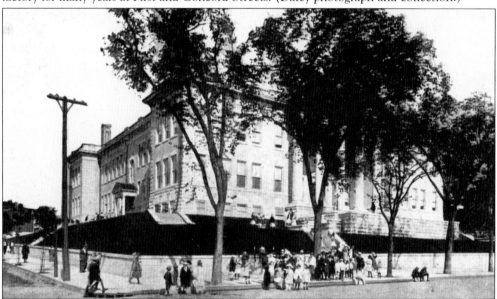

Broadway School, at the corner of Robinson Avenue, opened its doors for the first time to more than 500 Newburgh children on September 7, 1910. This photograph was taken a year later. Designed by well-known architect Frank Estabrook, the school had an auditorium that seated 800, making it an excellent place for the community to hold meetings and the school to provide free lectures and adult programs. (Whitehill collection.)

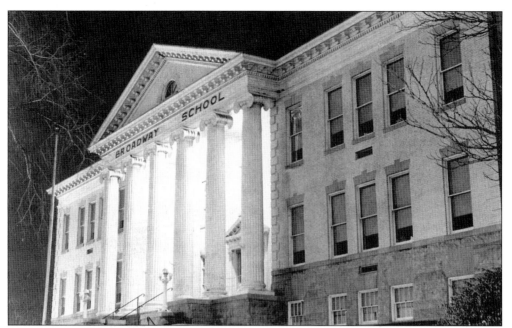

This nighttime photograph of Broadway School, taken in 1960, accents the grandeur of the building. Often mistaken by visitors as Newburgh City Hall, the building was almost used for that purpose when the school district sold it to the city in the 1980s. Monies to convert the structure never materialized, and for a number of years, the school remained unoccupied. (Aiello photograph, Historical Society of Newburgh Bay and the Highlands collection.)

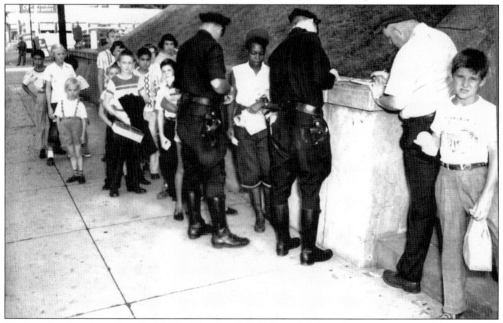

During the 1950s and early 1960s, Newburgh's Police Athletic League sponsored bus trips to baseball games and other attraction for local children. Here, in front of the school, patrolmen register the children—many holding bag lunches for the daylong event—who then board buses that take them to their destination. (Goodbread collection.)

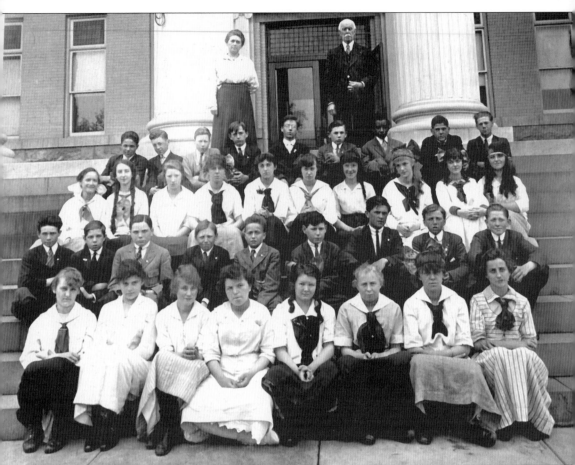

In this 1916 Broadway School graduation photograph, teacher K. A. Flanagan and Principal William Kelly stand behind the students on the steps of the school. The graduates are, from left to right, as follows: (first row) Blanche Post, Anna Murray, Mable Frost, Elsie Denman, Marion Brundage, Eleanor Miller, Bessie Strickland, and Elizabeth Blume; (second row) John Ralph, Kenneth Plant, George Northrop, John Snyder, Charles Anderson, William Smith, Frank Jackson, Wallace Terpenning, and Hugh Clark; (third row) Leah McClur, Ruth Milliken, Ethel Seaman, Beulah Strickland, Mary Doderer, Ruth Elliot, Grace Seaman, Evelyn Miller, Marguerite Canniff, and Helen Keesler; (fourth row) Onorfrio Genova, William Kennedy, Ervin Hamilton, Herbert Greenwood, Lawrence Van Duzer, Clarence Swain, Patrick H. Fox, Albert Newsome, and Kenneth Clark. (Yablonsky collection.)

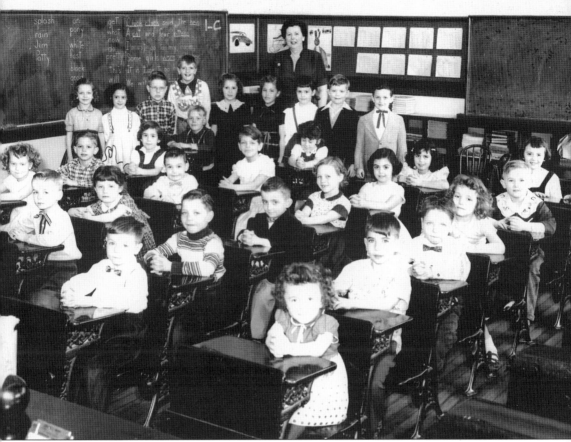

A Broadway School class poses in June 1955. Seated from front to back, beginning on the right, are the following: (first row) Phyllis Bishop, Frank Daly, David MacEntee, Ann O'Dell, Richard Titanic, and Frances Greene; (second row) Kenneth Noe, Daniel Heter, Alan Tomer, Jeanette Partington, Joanne Giammarco, and Patricia ?; (third row) Richard Roberts, Donna McLaughlin, Warren Patterson, Anita Wolozin, and Catherine Kehoe; (fourth row) Stephanie Cooper, James Milliken, Rosemary Valentine, and James Cornelius. Standing in the back, from left to right, are Susan Willard, Janice Megna, Irving Hamilton, Joseph Wagner, Virginia McElfresh, Leona Zuchowski, teacher Eleanor Counant, Anne Staples, Charles Davis, and John Early. (Historical Society of Newburgh Bay and the Highlands collection.)

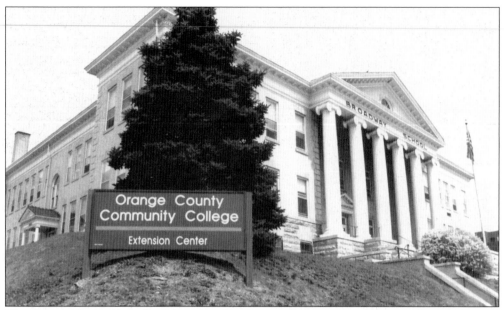

The former elementary school became the Orange County Community College Extension Center in 1990. In May 1992, the college held its first graduation exercises, and the center grew at a rapid pace. Needing more room, the college moved to the Key Bank building on lower Broadway a few years later. For the next four or five years, the building served as an elementary school once again. It closed in 2003, its fate unknown. (Favata photograph and collection.)

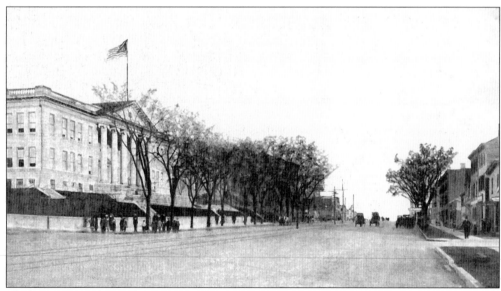

This rare postcard view looks east in the 1920s from just beyond Robinson Avenue. On the south side corner, at the far right, was Relief Laboratories, maker of proprietary medicines. Chester Brown was president of the company. Many of the buildings on the block were residential, but Deisseroth Brothers Garage, which sold Packards and serviced Oldsmobiles and Chevrolets, occupied numbers 291–293 Broadway. (Yablonsky collection.)

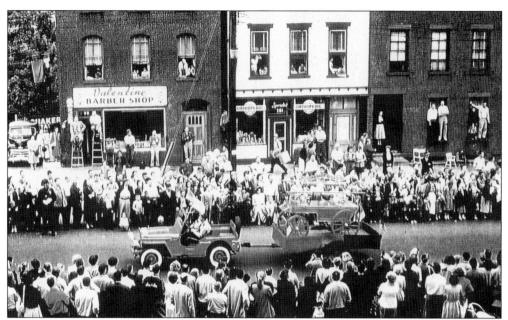

People watched parades not only from the street, as this 1940s photograph shows, but also from their windows, on sills, and on ladders. This was a common practice and assured a good view. In the background are Nick Valentine's Barber Shop and Silvio Eaani's Shoe Repair. (Valentine collection.)

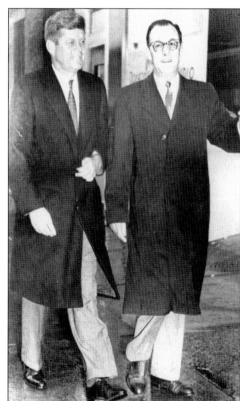

In 1959, Sen. John F. Kennedy (left) came to Newburgh to help Mayor William Ryan in his reelection campaign. This photo postcard shows Ryan escorting the future president down Broadway after having formal portraits taken at Donato's Studios. Ryan was successful in the election and served a total of eight years as mayor. (Whitehill collection.)

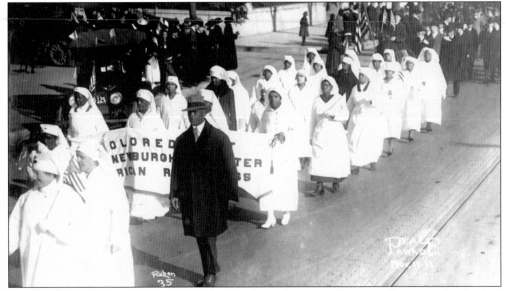

The *Newburgh News* account of the Peace Parade on Armistice Day gave the reason for the Red Cross's prominence in the festivities. The article states, "In every area during the war the Red Cross has figured largely and should have a place of honor at the close of the troubles." Here, African American women, in what was referred to at the time as the Colored Unit of the Red Cross, march past the corner of Robinson Avenue and Broadway. (Ruben photograph, Historical Society of Newburgh Bay and the Highlands collection.)

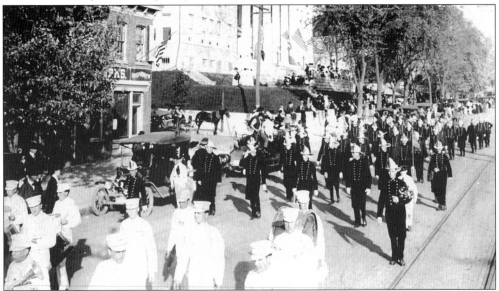

Newburgh and Cornwall firemen, along with 20 pieces of their apparatus, took part in the parade. The line of march also included Civil War veterans and more than 1,000 local workers who had supported the war effort at home in factories such as Sweet Orr, Cleveland Whitehill, and DuPont. Hundreds of Newburgh schoolchildren also participated. It was a perfect day for a parade, with thousands coming from surrounding towns by train, trolley car, boat, wagon, and automobile. (Ruben photograph, Historical Society of Newburgh Bay and the Highlands collection.)

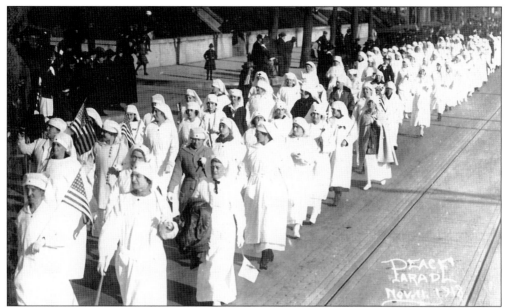

The Red Cross parade unit was comprised of more than 300 women from Newburgh and Cornwall. One of the services these women rendered during the war was the operation of a canteen. The women met the troop trains daily, providing coffee, sandwiches, gum, chocolates, and cigarettes. They served an average of 1,500 men daily and, on one day, provided refreshments to 7,000 troops. (Ruben photograph, Historical Society of Newburgh Bay and the Highlands collection.)

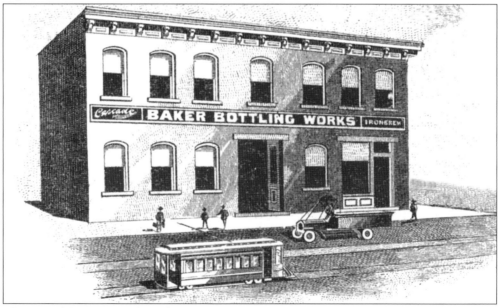

The second location for the Baker Bottling Works plant and office was at 308–310 Broadway. Established in 1875, Baker was a manufacturer of high-grade carbonated and distilled water and was the sole bottler of Iron Brew, Cherry Cheer, Jersey Crème, Cascade ginger ale, Vin Fiz, Grape Julep, and Marrowfood in Orange County for the first 25 years of the century. (Cavalari collection.)

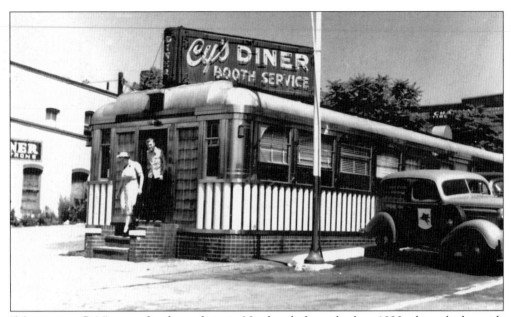

"Meet me at Cy's" was a familiar refrain in Newburgh from the late 1930s through the mid-1950s. Located on the north side of Broadway across from the school, it was one of the first places in the city to have a television set. One of the patrons' favorite programs was the broadcast of live horse racing. More than one diner was known "to place a winning bet" before a bookmaker was aware of the results. (McTamaney photograph and collection.)

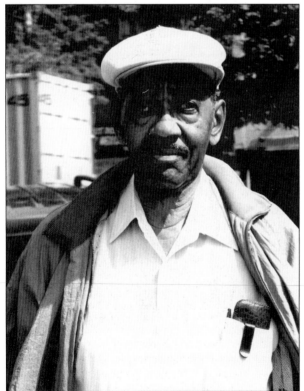

Grady Parker, a longtime Newburgh resident, was a cook at Cy's for a number of years. Raphael Egan, a prominent local judge, often ate at Cy's. One day he asked to talk to the cook. Egan told Parker, "You make the best pot roast I have ever eaten." After that, when Egan came in for dinner, he would ask if Parker was working. If he was, his standard order was pot roast. (Favata photograph and collection.)

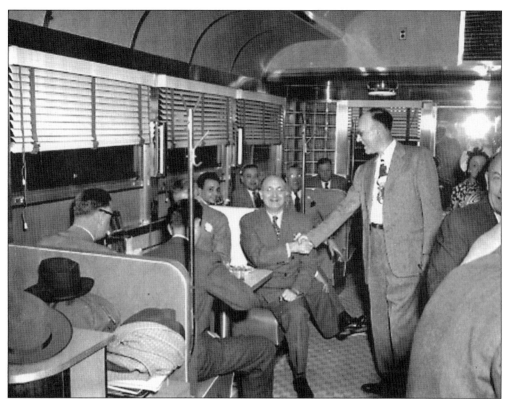

Cy's owner Irving Rubin shakes hands with one of the patrons, most likely Court of Claims Judge Daniel Becker, who also served 10 years in the state assembly. The diner was known as a place where local businessmen met. Seated at the table behind Becker are Gus Vollar (left) and Phil Levy (center). (Goodbread collection.)

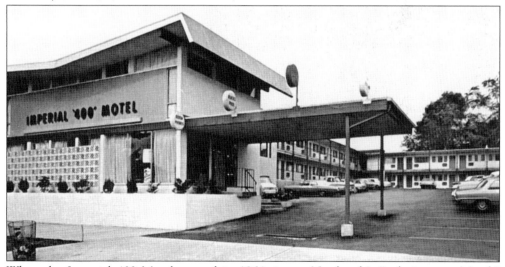

When the Imperial 400 Motel opened in 1964, it was Newburgh's "only in town Motel." According to the advertisement on this postcard, it was "convenient to shopping, the business district and restaurants." The motel also had a heated swimming pool, in-room television, telephones, central heating, and air-conditioning. (Whitehill collection.)

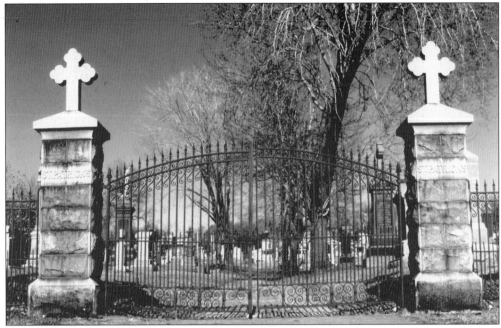

Shown here are the gates to St. Patrick's Cemetery, the oldest Catholic cemetery in the area. When it opened for the first burial in 1880, the average life span was 45 years. In the middle of the cemetery is a World War I memorial, which often served as the destination for horse-drawn carriages in patriotic parades from lower Broadway. (Daley photograph and collection.)

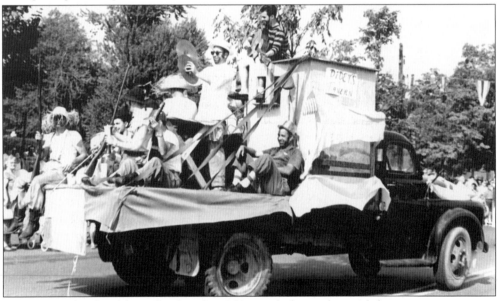

In 1959, Newburgh celebrated its founding 250 years before with a week-long anniversary party. One of the largest events of the week was a 12-division parade featuring floats made by clubs, businesses, civic groups, and the military. More than 3,000 people marched in the parade and tens of thousands watched. In this photograph, a young Vinnie Clavio, now a local restaurateur, sits atop his family's float. (Annan photograph, Historical Society of Newburgh Bay and the Highlands collection.)

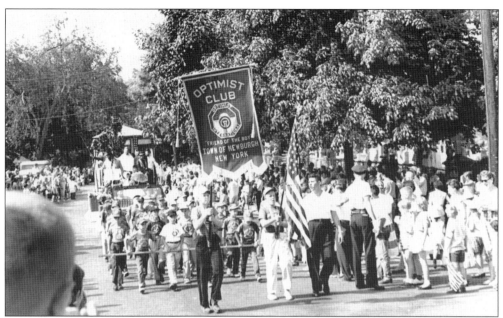

Parade participants came from many places throughout Orange County and the state. The above photograph shows the Newburgh Optimist Club, and the lower one displays one of the historical society's entries. Jeanne Shipp is the young girl in the carriage. All through the week of July 5, a pageant was held nightly on the grounds of the Newburgh Free Academy. The professionally produced dramatic presentation *The Story of Newburgh Bay* was a nine-episode history of the city and featured a cast of hundreds of locals. Some 2,000 people attended nightly. Following the play, both ground and aerial fireworks took place. Many children, including some shown above, took part in the evening festivities. The celebration committee, headed by Frank Finnegan, president, produced a 16-page souvenir booklet. (Annan photographs, Historical Society of Newburgh Bay and the Highlands collection.)

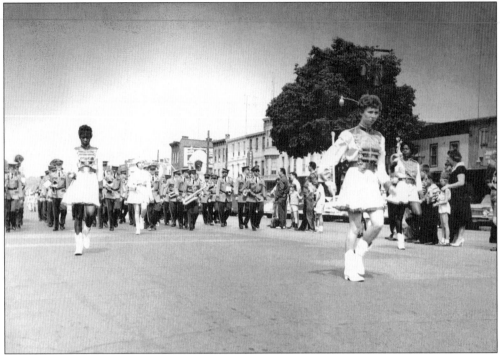

The Newburgh Free Academy band marches, awaiting its cue to play, in this 1960 Memorial Day Parade photograph. Some seniors in the band were Herbert Berkwits, Peter Berkowok, Lawrence Bockar, Melvin Lacey, Robert Meneely, Lyn Monroe, Dotty Norvell, Henry Siebert, Kent Sinisgalli, Carol Weiss, and Richard Wollman. Jennie Mae Root is the majorette in the lead to the right. (Goodbread collection.)

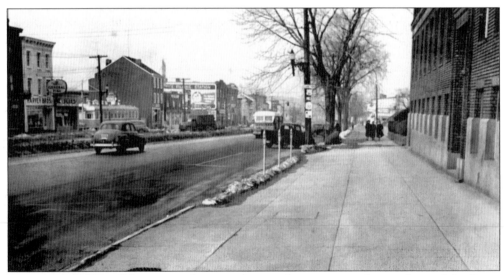

A preview of what will be seen in the next chapter, this view was taken in front of the Sweet Orr building looking southwest. Shown are the Harvey Brothers' Tire Store, the Park Diner, and Manufacturer's Men's Clothing Outlet. On the other side of Robinson Avenue are the Park Filling Station, John J. Lease Real Estate, and the Park Theatre. (Goodbread collection.)

Four

THE MILL WORKERS

When Broadway was first brick paved in 1904, it was only surfaced to Mill Street, one block east of Robinson Avenue. The reason for this was the limited population in the west and, some people believe, the makeup of that population. Many in the west end were foreign-born mill workers and not businessmen like their counterparts on lower Broadway. Looking at newspaper articles from the early part of the century, many Irish and other foreign nationals are portrayed as "roughnecks, drunkards and hooligans."

Most of the housing in the area consisted of frame buildings, and large tracks of land were devoted to a single enterprise, for example Schaeffer's Nursery, Crook's Bakery (NBC), and Weller Coal on the south side of Broadway at Lake Street.

Even Grace Methodist Church had a relatively large lot when it was first built. From the 1920s on, this part of Broadway experienced growth and change, including the paving of Mill Street to West Street and eventually all the way to the city line.

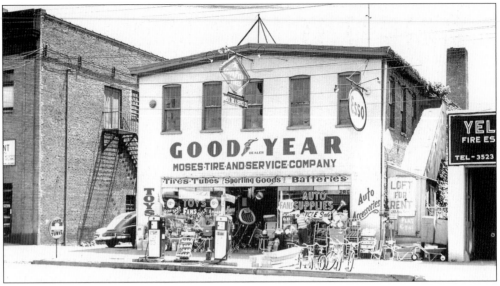

For many years, the Moses family ran the Moses Tire and Service Company, on upper Broadway. Over time the family added items not usually associated with a tire store, a phenomenon common to small city stores on major thoroughfares. Among the items seen for sale in this photograph are fans, beach balls, bicycles, garden tools, and picnic supplies. Signs in the window advertise fans, tackle, and other products. (Bloomer collection.)

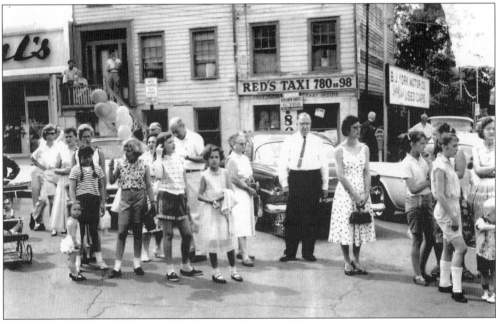

David J. and C. Evelyn Perrott stand just to the right of center, waiting for a parade to go by. Longtime Broadway business Pearl's Appliance (far left) and Red's Taxi (right center) surround a residence. At one time, this section of Broadway was more residential than commercial. (Whitehill collection.)

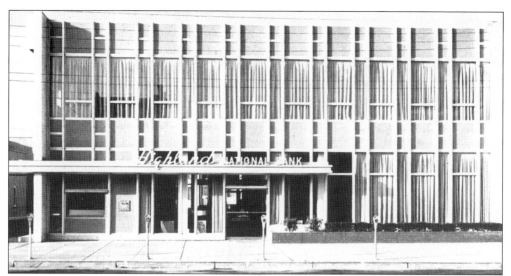

Highland National Bank was first chartered in the city in 1834. After acquiring numerous other banks and moving to various locations, it built its new headquarters at 385 Broadway in 1958. The architect for the new bank was Gordon Marvel, a local citizen who designed many public and school buildings. (Whitehill collection.)

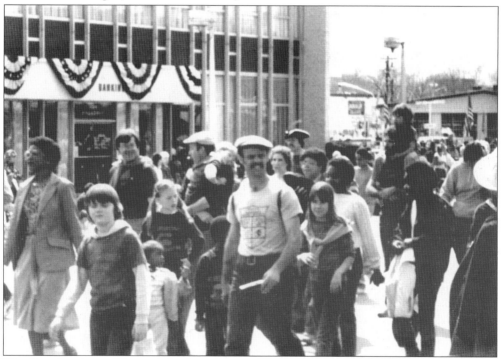

The Revolutionary War ended when George Washington issued a cessation of hostilities proclamation here in 1783. Thus, Newburgh played an important role in the bicentennial of 1983. Students, parents, and teachers from the Horizon Magnet School march past the bank in this photograph of the bicentennial parade. Student Larry Noonan is second from the left; parent Al Favata appears in the center; teacher Ray LeDuc, in the right background, carries a student on his shoulders. (Whitehill collection.)

In the late 1960s or early 1970s, Steve Tsangarakis and Andy Phillips opened Newburgh Lunch. Tsangarakis, one of the three original Texas Wiener Kings in Newburgh, made the famous wiener and sauce for most of the 20th century. Phillips, usually with a line of hot dogs up his left arm ready to be sauced, is seen here watching the magic sauce and onions. Ironically, a McDonald's can be seen through the window. (Favata photograph and collection.)

Bobby Bennett's was a popular watering hole in Newburgh for many years. Moving from Washington Street to Broadway in the late 1970s, it stood at the beginning of the block on the north side from Prospect Street. On the corner was Signal Finance, followed by Newburgh Lunch, the Elbow Room, Broadway News, Lino and Attillio's Barber Shop, Favata's Bakery, and then Bennett's. (Daley photograph and collection.)

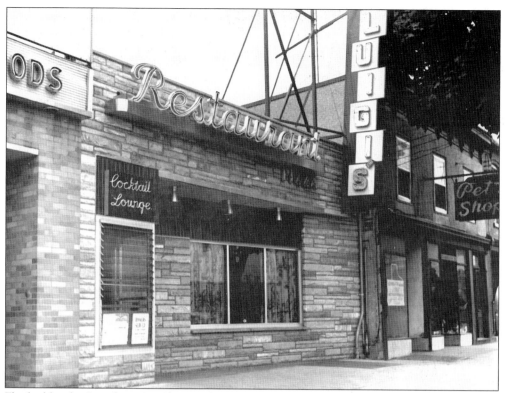

Flanked by the Broadway Pet Shop and Kinney's Sporting Goods, Luigi's was founded in 1939 and was owned and operated by Frank Barossi and Paul Lasini. It was a classic Italian restaurant, with the motto "It may take a little longer but our foods are individually prepared to your taste." (McTamaney photograph and collection.)

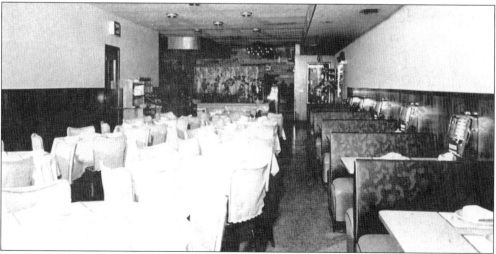

Pictured here is the Luigi's dining room in 1962. Choice wines and liquors were available at the bar or with meals. Complete dinners could be ordered, as well as à la carte items available, anytime from noon to 1:00 a.m. Before the two bought Luigi's, Frank Barossi was associated with Café Arnauld and Paul Lasini with Longchamps, both in New York City. (Yablonsky collection.)

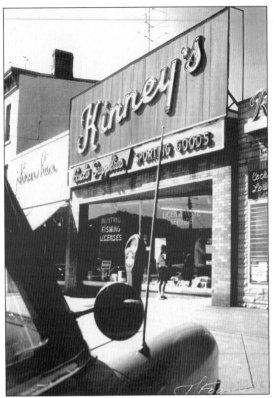

Kinney's Sporting Goods Center was the ultimate location for area sportsmen. It offered not only equipment for the hunter, fisherman, or sports enthusiast but also all the appropriate licenses for sports in season. In a unique combination with sporting goods, Kinney's also sold auto parts under the same roof. (Fogarty photograph and collection.)

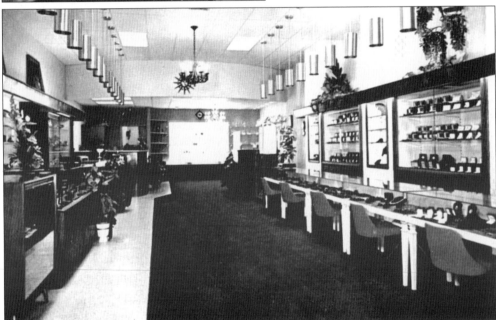

This postcard shows the interior of Galindo and Mills Jewelers, located at 374 Broadway. Joe Galindo and Nelson Mills owned and operated the store, which advertised its business as "the most beautiful and luxurious gem and jewelry fashion in the Hudson Valley." The store also carried a fine line of giftware for every occasion. (Galati photograph, Yablonsky collection.)

Schaeffer's Nursery occupied all property from 378 to 386 Broadway at the beginning of the 20th century. The interior of one of the greenhouses is shown here. The Schaeffer family—and other stockholders—operated the business under the Schaeffer name until selling to a man named Butler, who ran the operation in his name until 1924. By 1925, the greenhouses had been replaced by buildings as the move uptown continued. (Historical Society of Newburgh Bay and the Highlands collection.)

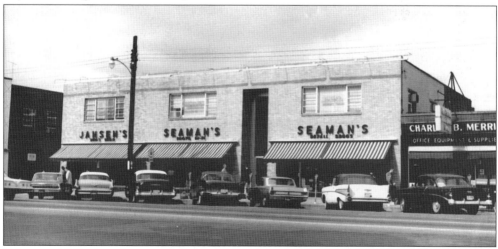

Taken in 1958, this photograph depicts four of the busiest stores on upper Broadway at the time. Jansen's was a quality men's shop. Seaman's Pharmacy, owned by Ed Seaman, sold drugs, cosmetics, surgical supplies, and had a large soda fountain. Seaman's partner, Harold Brown, owned the Photo and Hi-Fi Shop. Merrill's, a longtime Newburgh business, was an office supply store. (McTamaney photograph and collection.)

Seaman's camera department developed film on the premises and sold many brands of equipment, including Agfa-Arriflex, Bell and Howell, Bolex, Leica, Nikon, Polaroid, Zeiss, Linhof, Ampex, and Telefunken. The hi-fi section of the store was located through a door in the camera shop. The room was carpeted on all sides and was filled with stereos and speakers, a sound room made for listening and choosing the best equipment within one's budget. (Cavalari collection.)

Galloway Ford occupied this site at 394–396 Broadway and a large lot at 600 Broadway. Ernest and Mary DeCrosta founded the West End Food Market next-door. In the 1950s, the store had a frozen food refrigerator 40 feet long, a meat counter 60 feet long, and a vegetable counter 40 feet long. The market also offered automatic checkout and air-conditioning. These were amazing amenities for a small grocery at the time. (Goodbread collection.)

In 1963, Mickey Travers Snyder and her husband, Phil Snyder, converted the Galloway building into the new home for Travers. Begun by Maurice Travers as a remnant store and later as a specialty silk and fabric store, the business switched entirely to specialty women's wear when it moved to the Academy building in 1935. Travers then moved to Water Street and finally back to Broadway. (Snyder collection.)

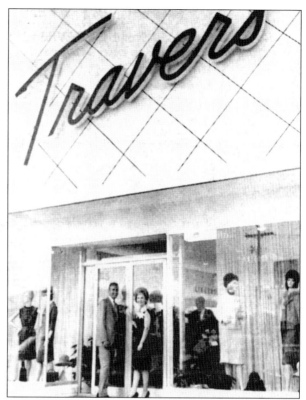

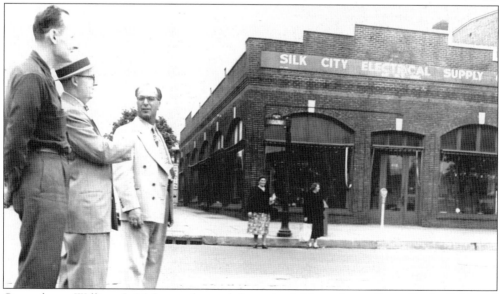

Councilman William J. McIntrye (second from the left) speaks to Oscar Reale (left) and another man in the middle of Broadway, with the Silk City Company, a major electrical supplier, in the background. Reale had just purchased the Silk City Company and planned two stores—a paint store and Braun and Real Glass—for the location. This building was another designed by J. Percy Hanford, in 1931, for Harry M. Austin, an automobile dealer. The building has been a restaurant in recent years. (Goodbread collection.)

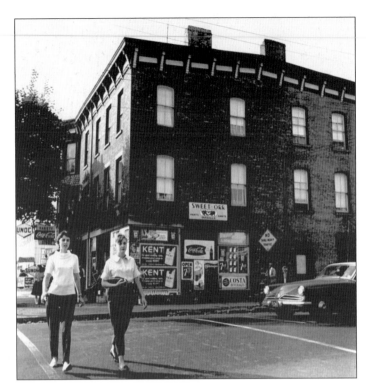

The Variety Store, on the north side at the corner of Fullerton Avenue, gave new meaning to the word "variety." It was an "everything" store with barely enough room in which to move. A member of the Ferraris family, who owned the store, could always find the item the buyer wanted. Sold were foreign language newspapers, plants, foodstuffs, toys, and as Mary McTamaney says, "even mousetraps." (McTamaney photograph and collection.)

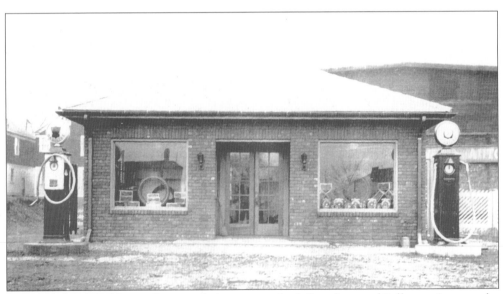

Situated behind the Variety Store, with driveways to both Broadway and Fullerton Avenue, the Sunoco gas station was operated by Johnny and Santo Antinori. Besides servicing cars and filling gas tanks, the Antinoris spent many hours fixing and filling bicycle tires for neighborhood children at little or no cost. (Goodbread collection.)

By 1970, the Variety Store and Johnny's were gone from this section of Broadway. Both moved farther up the street, past West Street. In their place came one of Newburgh's first fast-food restaurants, Jack-in-the-Box. Initially successful under the management of Louis Chouinard, the store closed in the 1980s. (City Records Management Department collection.)

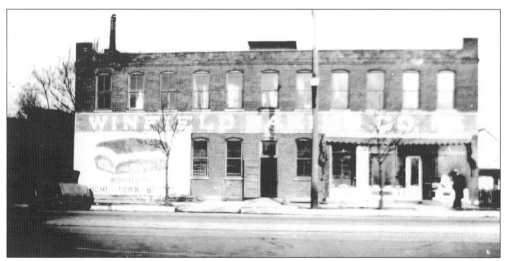

Winfield's Bakery is a 90-year study of a building and, ultimately, its adaptive reuse. Built in 1915 by the Crooks to provide bread and rolls for their restaurant and delivery business, it was sold to Charles Winfield in 1922. Billed as the first modern bakery in the Hudson Valley, Winfield's was sold to the National Bread Company in 1927. (Yablonsky collection.)

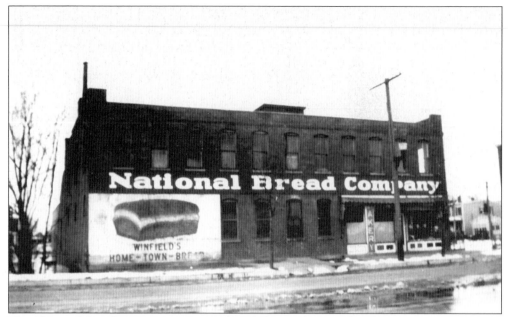

The National Bread Company continued to bake products under the Winfield name for a number of years. The company added a large addition to the rear of building in 1928. By 1935, it employed 35 people, had a fleet of 15 trucks, and made deliveries within a 40-mile radius. The products carried a red eagle insignia on the packaging. (Yablonsky collection.)

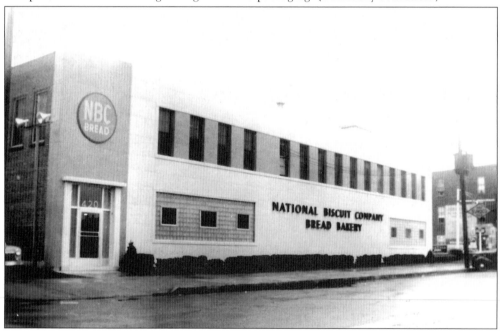

The National Biscuit Company took over the operation of the bakery c. 1940. The company modernized the equipment and renovated the façade of the building. In its next incarnation, the building became a vacuum bag factory, manufacturing not only bags but also floor polishers and built-in residential vacuum systems. At the end of the 20th century, it was an auto parts store. (Yablonsky collection.)

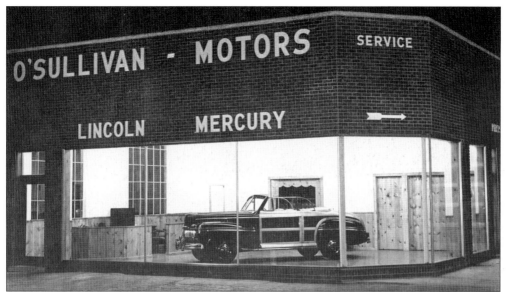

George O'Sullivan was involved in many businesses throughout his lifetime. One of his ventures, O'Sullivan Motors, was the local Lincoln-Mercury dealership in the late 1940s and early 1950s. The interior of the showroom was finished in knotty pine, a popular building material used at the time. Wood was also a very popular accent, as can been seen from the wood finished panels on this coupe. (Galati photograph and collection.)

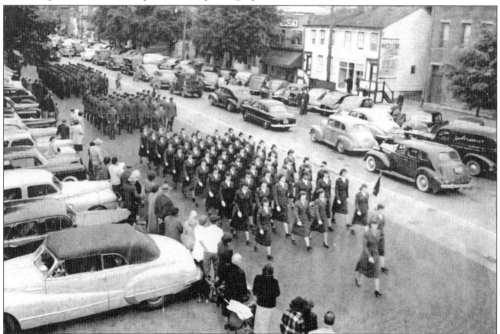

Members of the Women's Army Corps march down Broadway in this military parade of the late 1940s. This section of Broadway was still primarily residential, with some stores with living quarters above. The stores included Suraci's Tailor Shop, Smith Shoes, the West End Dress Shop, dentist Dr. McGrath, Phil Levy Confectionery, and past the church, MacDowell's Department Store. (Goodbread collection.)

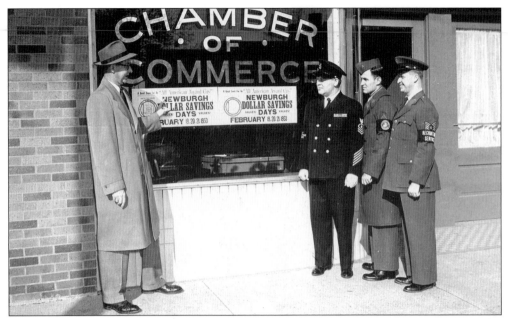

A Chamber of Commerce member points to the Dollar Days Saving sign on the front of the chamber office, at 464 Broadway, as military personnel look on. These savings were part of All American Days in February 1953. The chamber, begun as the Board of Trade in 1900, was devoted to the "promotion and development of all interests in Newburgh and its suburban localities." (Historical Society of Newburgh Bay and the Highlands collection.)

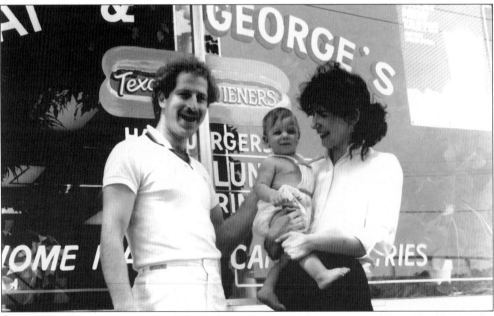

George Koundounas, a graduate of the Culinary Institute of America, and his wife, Alexis, who also attended the Culinary Institute, pose with their daughter Patrice in front of their newly opened eatery. In December 1984, Koundounas and Pat Sophocles opened Pat and George's Restaurant in the former Ma and Pa's. The restaurant remained open until 1989; it later reopened in the same location in 1995. (Koundounas collection.)

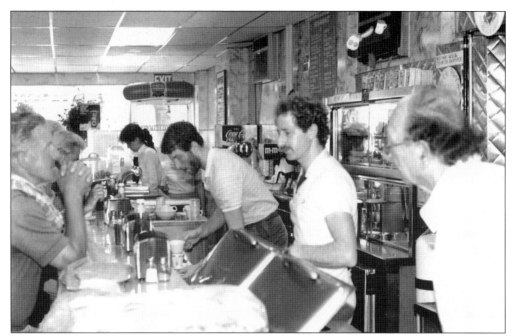

Pat Sophocles (right) and George Koundounas (second from the right) serve patrons at the counter in this 1984 photograph. Sophocles, former owner of Pat's Texas Hot Wieners, brought his famous sauce recipes to the partnership. Koundounas, an award-winning pastry chef at the Thayer Hotel at West Point, brought his expertise to the business. Together, they created an extensive menu featuring both American and Greek cuisine. (Koundounas collection.)

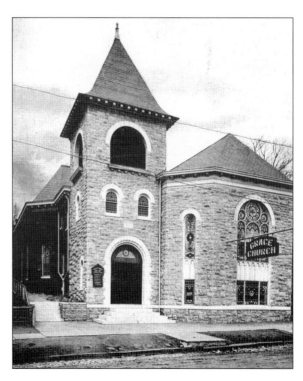

The original part of Grace Methodist Church was dedicated on September 2, 1868. Undergoing many changes and additions over the years, the last major addition was completed in 1963. In that year, Grace had a membership of 1,000 and a Sunday school attendance of more than 600 each Sunday, the largest of any Methodist church in the Hudson West District. The pastor in these very busy years was Rev. A. Gordon Archibald. (Cook photograph, Grace Methodist Church collection.)

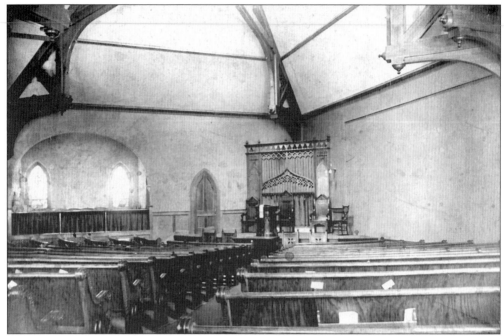

Taken shortly after the new church was completed in 1905 under the pastorate of Rev. E. M. Kniskern, this interior shot shows how beautiful the sanctuary was in its simplicity. The land for the original church, which this building replaced, was given by Gen. William Brown and his brother Charles. The church is made of brick with a stone front. (Historical Society of Newburgh Bay and the Highlands collection.)

In 1959, the Women's Society of Christian Service at Grace Methodist Church posed for a photograph. Identified are the following: (first row) Gladys Archibald, second from the left; Charlene Crowell, fourth from the left; Marion Shea, fifth from the left; and Olga Fear, sixth from the left; (third row) Bernice Wagel, fourth from the left; and Louise Smith, fifth from the left; (fourth row) Marjorie Vandermark, third from the left; (fifth row) Minnie Fullerton, second from the right. (Cook photograph, Grace Methodist Church collection.)

Grace Methodist Church also had an active junior choir in the 1950s and 1960s. In 1959, members included, from left to right, the following: (first row) Shirley Mazzarelli, ? Montgomery, unidentified, Gus Glassey, two unidentified, and Timothy Brown; (second row) Fran Olsen, ? Montgomery, Barbara Wack, Connie Light, unidentified, Marlene Barr, Leslie Wack, Michelle Mitchell, and Linda Arnold; (third row) three unidentified, Jeff Glassey, Chris Townsend, Stephen Markuson, and Gordon Millard. (Cook photograph, Grace Methodist Church collection.)

Among the members of this Girl Scout troop are the following: (first row), leader Connie Betz, left, and Linda Mazzarelli, right; (second row) ? Matagora, second from the left; (third row) Jean McDonald, the tallest girl, and Sharon Mims, right. (Cook photograph, Grace Methodist Church collection.)

The two pictures on this page depict the last portion of the northwest side of Broadway to West Street. The above scene includes, from left to right, one of Newburgh's oldest businesses, the Commodore, world famous for its chocolate creations; No. 1 Chinese Restaurant, a relative newcomer; J & F Pizzeria, a longtime business; and Baxter's Home Health Care, which sold surgical and health care supplies. In the lower photograph, Baxter's Pharmacy, which C. W. Baxter took from infancy in 1918 to retirement in 1965, is shown. A banner year for Baxter was 1953, when he filed his five-millionth prescription. The Nakashian family bought the pharmacy in 1965 and it closed in 1992. (Daley photographs and collection.)

In 1935, the Courtunis and Striphas families opened the Commodore Chocolatier at 482 Broadway. Originally selling homemade ice cream as well as homemade candy, the store now ships its fine chocolates and other specialties around the globe. Above, George Courtunis makes ribbon candy for the 1967 Christmas season. He is pouring a cooked candy mixture onto a stainless steel slab table to be hand worked. (Frangos collection.)

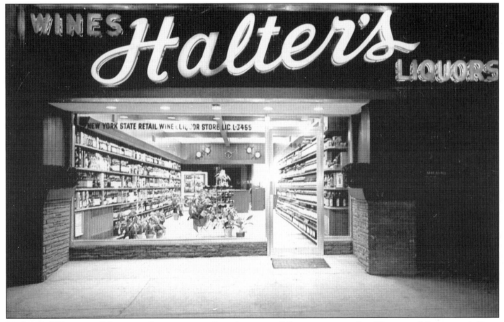

Halter's Wine and Liquor Store was a family-owned business run by George, Mary, and Don Halter. Located at 484 Broadway, Halter's promoted itself in the 1960s as "a new modern self-service store featuring domestic wines and champagne and a complete line of imported wines and liquors." (Whitehill collection.)

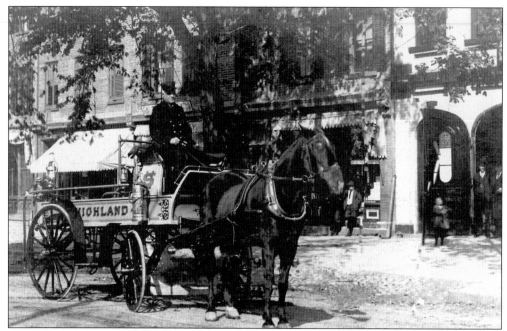

Highland Engine Company No. 3 was formed in 1866 and, a year later, built this firehouse, designed by local architect Elkannah Shaw. Constructed by Brown and McKeekin of Newburgh, the house is still used by the fire department. In this 1905 photograph, the firehouse appears on the right. (Jordy collection.)

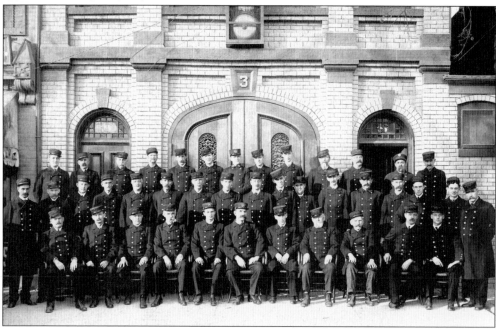

Proud members of Highland Engine pose in front of their ornate firehouse at the beginning of the 20th century. In 1866, some of these men met in the neighborhood store Ostrander's to form the company. In 1882, they purchased a new steamer for the house costing $5,000. They sold their old one to the village of Florida. (Whitehill collection.)

In this view of the south side of Broadway up from Lake Street, a woman and her two small children select a Christmas tree by the Grand Union store. Merchants often sold holiday plants, wreaths, and other foliage in front of their businesses before the Christmas and Easter holidays. (Historical Society of Newburgh Bay and the Highlands collection.)

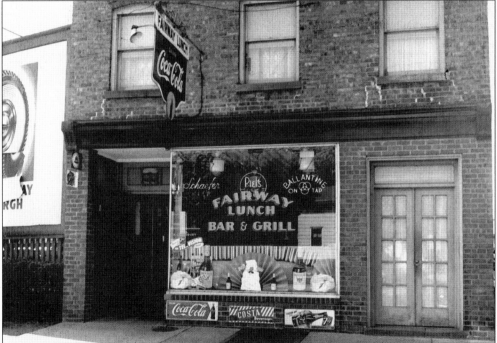

Fairway Lunch was open for breakfast as well as lunch. Across the street from O'Sullivan Motors, it featured well-known beers and also sold Newburgh's own Costa soda. The Costa family manufactured a variety of soda flavors for more than four decades in the latter part of the 20th century. (McTamaney photograph and collection.)

Beverwyck Breweries had a small distributorship on upper Broadway for many years. In addition to distributing its beer, it produced an Irish Crème ale. The brewery, located in Albany, produced 60,000 barrels (1 barrel equaling 31 gallons) in 1918, the year it was incorporated. Local collectors can still find coasters and trays with the Beverwyck name. (Goodbread collection.)

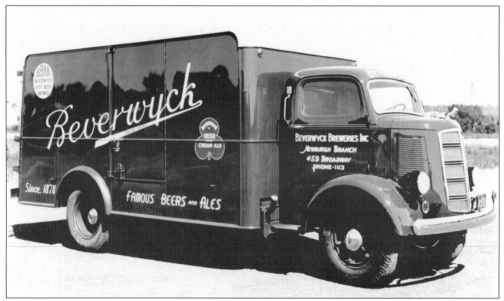

A 1939 truck with the Beverwyck sign made all the deliveries to the local bars and restaurants in the area. Beverwyck stayed in the beer-brewing business until it sold its plant to the F & M Schaeffer Brewing Company in 1950. At the time of the sale, Beverwyck was making over one million barrels of beer a year. (Jordy collection.)

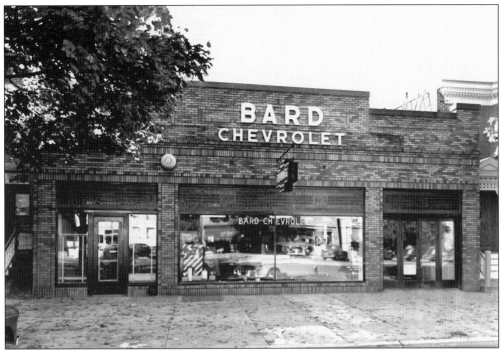

Home to other dealerships for many years, the new Bard Chevrolet building was constructed by the J. A. Fogarty Company in the late 1940s. In 1967, in order to keep up with the demands of increased business and to provide better service, Donald Bard modernized and expanded his facility. One improvement was a glass showroom, which made the facility a total of 42,000 square feet. (Flannery collection.)

Louis Tarr, for years the owner of Leon Neon on lower Broadway, built this commercial building on upper Broadway in the 1950s. He hoped the trend to move uptown would continue and saw this as a positive business move. Tarr was also very charitable, donating money to many local causes. Tarr Oval, a baseball complex in the town for many years, was named for him. (Goodbread collection.)

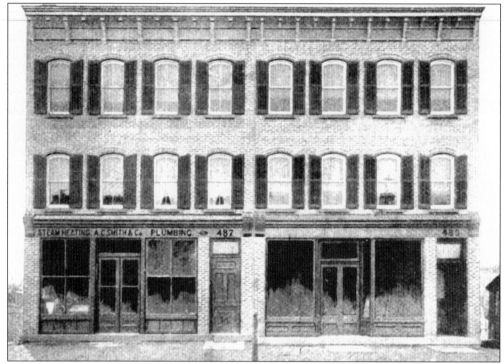

Specializing in plumbing and heating systems, A. C. Smith was founded in 1877. As the years passed, Smith added many other services, including the installation of sprinkler systems, water pumps, and sewage disposal systems. A branch of the business existed in Fishkill for some time. After more than 100 years at its Broadway location, the firm closed in the 1990s. (Historical Society of Newburgh Bay and the Highlands collection.)

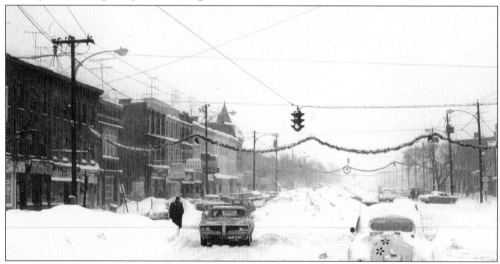

This view looks east down Broadway from West Street on a snowy day in the 1980s. Sparse Christmas decoration can be seen draped across the street. Newburgh was well known for its elaborate holiday lights and decorations on the business streets such as Water Street and Broadway in the early part of the century. People from surrounding communities would come here to show their children the festive sights. (Daley photograph and collection.)

Five

TO THE CITY LINE

In the beginning of the 20th century, this section of Broadway was comprised of factories, mills, large commercial establishments, boardinghouses, small farms, and some 60 homes. Although the area was sparsely populated, the trolley did pass through, and a trolley barn was located at the Wisner Avenue intersection. This gave workers living in other parts of the city easier access to their jobs in West Newburgh.

In the early years, the Newburgh Yarn Mills (later, Stroock) and Crawshaw Carpets employed hundreds of people. In the 1920s, the Newburgh Lumber Company built on a large tract of land west of Washington Terrace on the south side of the street. In the 1950s, Harold Galloway transformed a large piece of land on the other side of the street into a thriving car dealership. Beyond Galloway's, on the north side, only a few buildings stood between his business and the coal pockets (towers) by Wisner Avenue.

As the century opened, just 18 homes stood on both sides of Broadway west of Wisner Avenue to the city line. One was a rooming house for workers, three were owned by the Harrison family and rented to employees, and the rest were private residences. Many of these homes had their own vegetable gardens and raised small animals for food. On the same block, a large greenhouse was owned by one of the Crawshaws.

By the end of the century, this section had become almost exclusively commercial.

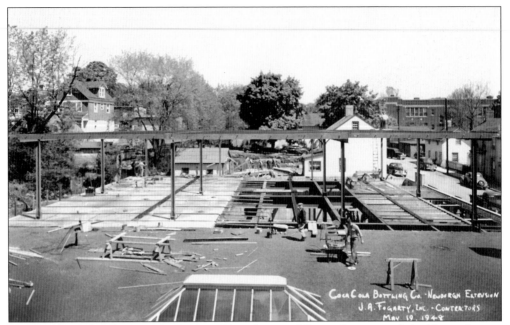

In 1948, the Coke Plant, on the corner of Broadway and Grove Street, needed additional space for its operations. The plant hired the J. A. Fogarty Company to construct an addition on the building. In this photograph, steel work goes up on the second floor of the plant. In the background at the far right, West Street School can be seen. (Flannery collection.)

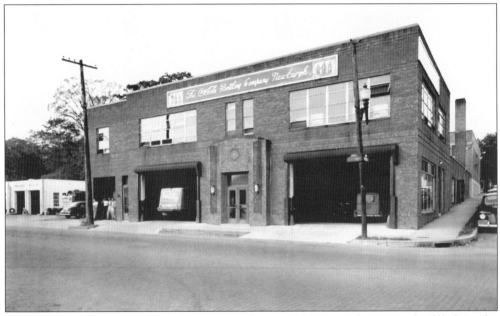

Workers stand in front of the finished Coke plant as delivery trucks wait to be filled. In the 1950s, schoolchildren took field trips to the building to watch the automatic bottling-and-capping machines. Neighborhood children who knew the building's secret could always find a warm bottle of coke in an unlocked closet in the back. (Flannery collection.)

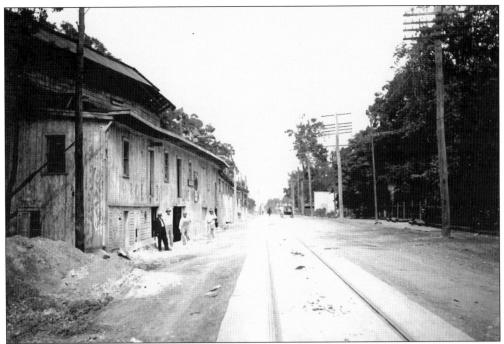

The above view, looking east, shows John E. Harrison's Lime Works, successor to the Brown Lime Works. DuPont Avenue stretches behind the building. At the beginning of 20th century, Harrison was a manufacturer of lime and sold building supplies for masons, as well as dynamite, powder, and fuses. A decade later, coal, sisal, and phosphate were added to the list of products sold, and Harrison had become a dealer in wool. By 1922, the enterprising Harrison had died, and the wooden building was replaced with a brick and masonry one. Shortly thereafter, the Orange County Reo Corporation moved onto the site and sold cars and trucks there until the early 1930s. The place then became the home of Nelbach's Garage. (City Records Management Department collection.)

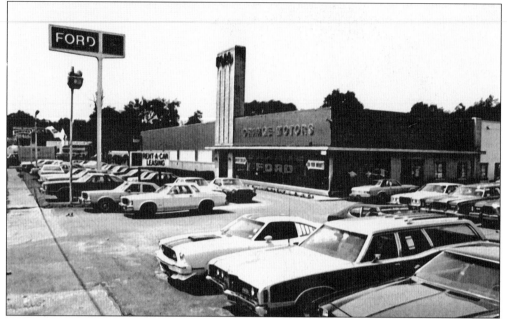

Frank Galloway, founder of Galloway Ford in 1920, decided to move his entire dealership to the four acres of land he owned at 600–620 Broadway in 1954. The new site handled all sales and service and had a truck sales and used car department. By 1959, a total of 62 people worked for Galloway, and his son Harold had joined him in partnership. Orange Motors took over the dealership in the 1970s. (Historical Society of Newburgh Bay and the Highlands collection.)

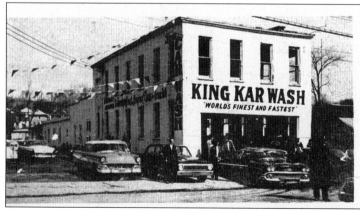

Nº **17079**

GOOD FOR ONE WASH
Any Day - Any Car

Protect and Beautify
your car.

With our professional
wax job.

We will pick up
and deliver.

Call JO 1-8650

650 Broadway,
Newburgh, N. Y.

The King Kar Wash was originally built to house the Baker Bottling Works. In the early 1930s, the business was operated by Samuel Leonardo, manufacturer of Italian soda. The venture was ahead of its time, and a dairy bar and luncheonette took its place. A laundry and dry cleaner then replaced the dairy bar. In the 1960s, the site became the car wash, with a nightclub of the same name on the second floor. (Whitehill collection.)

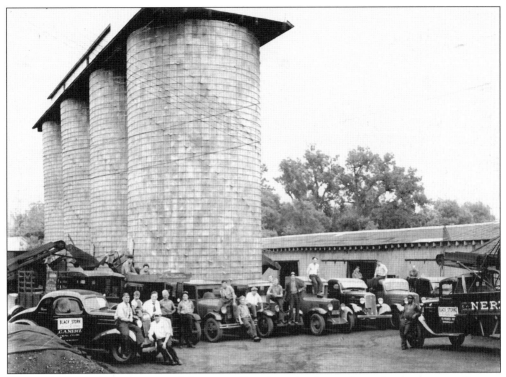

The coal towers that were part of the upper Broadway landscape for so long were actually part of a business operating on Wisner Avenue. In 1924, Clement Nerz, who owned the business for many years, advertised that he had "the most modern coal plant in the Hudson Valley." In the early 1950s, the plant became the Black Stork Coal Company. After the towers were demolished in 1971, the site becoming a car wash. (Historical Society of Newburgh Bay and the Highlands collection.)

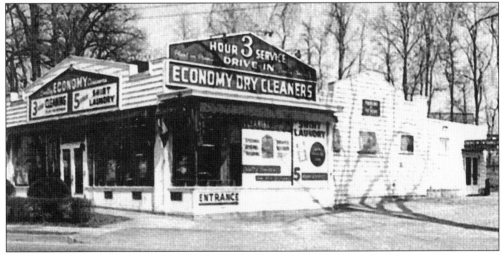

In 1947, Economy Cleaners was founded by Philip Snyder and his wife, Mickey. The business began on South Plank Road and then moved to 690 Broadway in 1950, when this photograph was taken. The business continued to grow, and in 1970, the quality dry cleaning and tailor shop moved to its present location, at 567 Broadway. (Snyder collection.)

The SAVINGS and LOAN ASSOCIATION of NEWBURGH

For most of its history, the Savings and Loan of Newburgh was known as the Building and Loan, with an elegant office located at 47 Grand Street. Well-known Newburgher Roy Curtis was chairman of its board of directors. In the 1970s, sometime after the bank had revamped and undergone a name change, John Flannery, successor to the Fogarty Construction Company, built this new headquarters close to the city limits. Gordon Marvel was the architect. (Whitehill collection.)

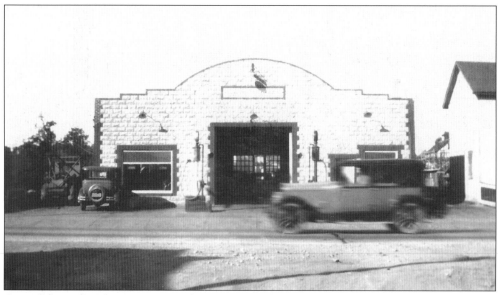

One of the earliest garages on Broadway was owned by Otto Pfleger in the early 1920s. Called the West Broadway Garage, automobile repair was its specialty. Within a few years, Harold Woodruff had bought the business, and he and his family ran the garage for more than 30 years. The building became a Rambler dealership for a time and is still used as originally intended. (Yablonsky collection.)

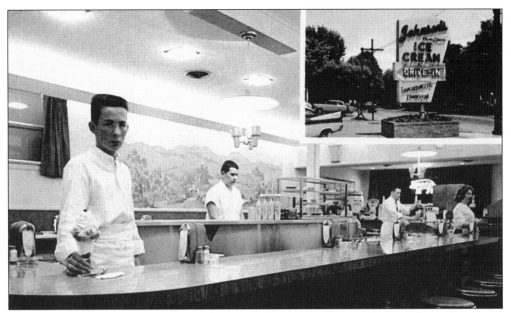

Johnson Brothers Ice Cream and Luncheonette, whose slogan was "Where folks go by choice, not chance," was famous for its Pig sundae, a huge ice cream concoction. Patrons who finished one were given a button to wear that proclaimed, "I ate a Pig Sundae." John V. Lahey appears at the front of the counter. (Favata photograph and collection.)

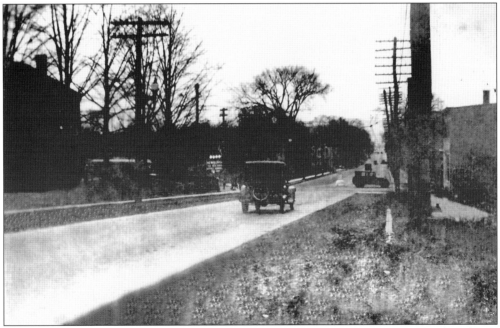

This car travels east on Broadway, past all the sites of the last century on the north side. It heads for Hargraves Market just up from West Street. The building on the left is a rooming house for the Crawshaw and Stroock workers, and on the opposite south corner once stood the trolley barn. (Yablonsky collection.)

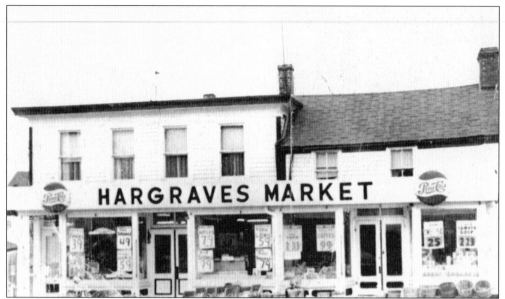

On July 27, 1966, a century-old landmark disappeared from the west Broadway scene. Hargraves Market, on the south side of the street just west of West Street, closed. When the market began operations, it was used as a base for peddlers who sold their wares from horseback. The store took its groceries and fish to locations as far away as Walden, Wurtsboro, Montgomery, and Ellenville. The son and grandson of the original owner, James and William Hargraves, respectively, sold the store, knowing that it would be razed for a Hess gas station. The lower photograph shows the "wide" aisles and "large" carts in the store. The stove in the back was the only heat the building had in its entire history. (Hargraves collection.)

In this view, looking south from the corner of Dupont Avenue, a private house can be seen on the corner of Broadway and Washington Terrace. Across from it, in the wooden structure, is Drobner's New and Used Furniture. The building behind that is the Ross Flour Mill. Behind the railing, a used car business operated, possibly in the same building shown in the next photograph. (City Records Management Department collection.)

This concrete block building was an auto repair shop and junkyard when it was offered for sale in 1969 for $40,000. At the time, it was zoned for light industrial use. In 1913, F. Herman and Son's Leather and Hides, a small steel mill, and a stone and materials shed occupied the site. (City Records Management Department collection.)

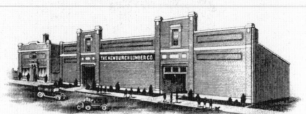

THE NEWBURGH LUMBER COMPANY

WHOLESALE AND RETAIL

LUMBER AND BUILDING MATERIAL

MAIN OFFICE: 603 BROADWAY

Once located at 229–239 Broadway, the Newburgh Lumber Company moved to 603–623 Broadway c. 1925. Another business founded by Samuel Stewart, the company took advantage of the large vacant tracts of land in the west end and the Erie Railroad's close location. The main office was located in the building at the far left of the above view. The yard's large doors permitted loads of material to be brought in and out. Newburgh Lumber closed in the early 1940s after the 1936 death of Stewart from pneumonia. The doors and façades were removed when the lumberyard closed, creating three separate buildings. Over the years, the buildings held various commercial, industrial, and even professional enterprises. The lower photograph shows one of the buildings as it looked in the 1980s, when it was up for sale. (Above, Whitehill collection; below, Goodbread collection.)

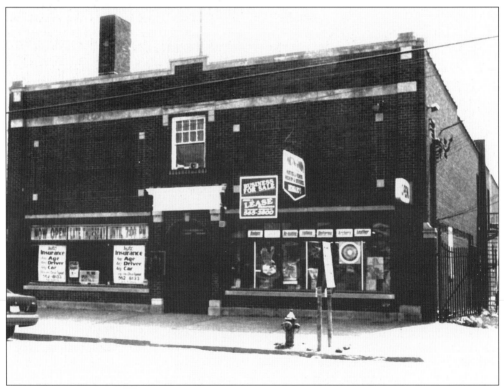

One of the most interesting business to occupy 603–605 Broadway was a bobby pin factory. Operating under various names, including Nellie Martin and Dolly Madison, the manufacturer stayed in business through the mid-1960s. The National Cash Register Company and the Angie Coat Company, among others, then used the building. (Favata collection.)

This small bridge crosses one of the many small tributaries making up the Gidneytown Creek. On the other side of the street stand the buildings of the former lumberyard. Some of the businesses that have located there in the last half-century include Rocco Handbags, Orange County Custom Cabinets, West Ceramic Supply, the Newburgh Coat Company, and the Style Wood Furniture Company. The long factory building past the lumberyard is the former Crawshaw Carpet factory. (Goodbread collection.)

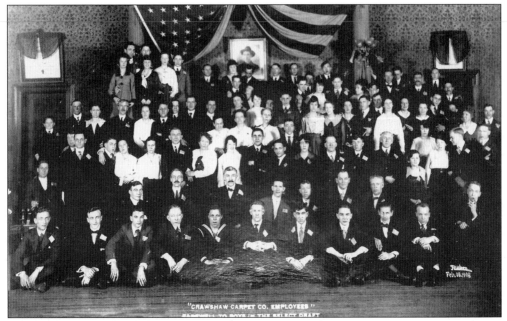

This poignant photograph was taken at the farewell party for Crawshaw Carpet Company employees going off to fight in World War I. The sadness of some, the patriotism of others, and the fear and loss of still others, as seen in the faces of the couples in the third row, is very moving. (Yablonsky collection.)

In 1878, Stroock and Company purchased an interest in the Newburgh Yarn Mills. In 1902, Stroock took over the mills and began manufacturing velours and plush fabrics in the plant. It sent fabrics worldwide and was a major contributor to the World War I effort, sending medical blankets, overcoats, and soldiers' blankets and robes to the front. This is an aerial view of Stroock in the 1950s. (Historical Society of Newburgh Bay and the Highlands collection.)

Stroock employees celebrate New Year's 1950 at the Green Room in the Hotel Newburgh. Dan Leo, a longtime administrator at Stroock, identified the people in this photograph before he passed away. Pictured here, from left to right, are the following: (first row) Nick Bianco and Harold Lozier; (second row) Tony Amen and Irving Avery; (third row) Jack Drennen, Art Patterson, Joe Corbo, David Engel, John Schitzler, Curt Richter, Steve Stroock, Jim Knowloen, LeGrand Roe, unidentified, and Joe Maloney; (fourth row) two unidentified, Ted Eberhardt, Fred Diehl, Erik Ferb, Albert Becker, Dan Leo, and Phil Leo; (fifth row) Bill Conyngham, Burt Conklin, Hal Schiller, Sylvan Stroock, unidentified, John Fesco, and Jack Shedd. (Goodbread collection.)

The Shop

featuring *Stroock*

The Stroock Shop was the local retail arm of Stroock and served the women of the region. It was located on the southwest corner of Broadway at Wisner Avenue. Originally Catania's Deli, it then became Catania's gas station and finally the outlet for Stroock's fine line of women's apparel. (Historical Society of Newburgh Bay and the Highlands collection.)

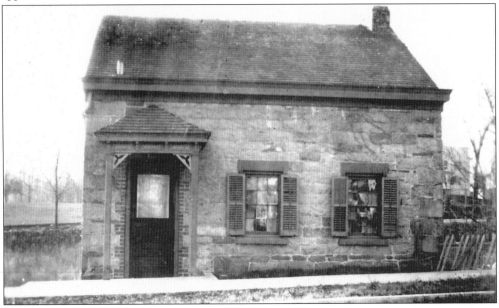

The residence at 711 Broadway was built more than 150 years ago and remained as such for more than 100 years. The structure is one of the few original stone buildings still on Broadway. During the 1930s, a second story was added, and later, a number of real estate agencies called it their home. They included Catherine Kovarovic in the 1960s and McCurdy and McEwen in the 1970s. (Yablonsky collection.)

One of the families to occupy 711 Broadway was that of Edgar Lyons. Lyons, who moved to Newburgh from Ulster County *c.* 1915, lived here and worked in the carpet mills. A cooper by trade, he raised chickens in his backyard. His granddaughter Barbara Yablonsky remembers that he often took her hunting for wild horseradish in the neighborhood. (Hansen collection.)

Gladys Lyons was the youngest daughter of Edgar Lyons. Here, she relaxes in a hammock in the family's backyard. An early amateur photographer, she took the photographs of the troops leaving for World War I, on page 55, in which her brother is pictured. (Hansen collection.)

Johnny Lyons, born in 1905, was Edgar Lyons's youngest son and Paul Yablonsky's grandfather. In this photograph, he was about 15 years old. He worked for a time at Woodruff's Garage, up the street. The Lyonses were descendants of a soldier who, after fighting in the War of 1812, moved his family to Ulster County and founded the community of Lyonsville. (Hansen collection.)

William Flynn lived at this house, at 715 Broadway, following World War I, as did the Edgar Lyons family for a brief time after the Flynns had left. One of the four houses owned by the Harrison family in 1903, it was probably rented to Harrison's workers at the silk mills or the carpet factory. (Hansen collection.)

"Johnny Lyons and his friends the 'Newsome Boys'" is written on this photograph. Sometimes only conjecture can be used to make sense of an unidentified image. The Lyons and Newsome families both lived on Little Britain Road at one time. Ben, George, and Frank Newsome, who were about the same age as Johnny Lyons (center), worked at Crawshaw's with Edgar Lyons. They had a younger brother. Are these the dapper young gentlemen? (Hansen collection.)

Following an accident, citizens await assistance to repair a dangling electrical pole in front of Colonial Esso on the southwest side of the street near the city line. The two frame houses in the photograph are in the typical style of one-family homes constructed in the 1920s in this area of Broadway. The area is now zoned for commercial use, and many of these homes are now business establishments. (Goodbread collection.)

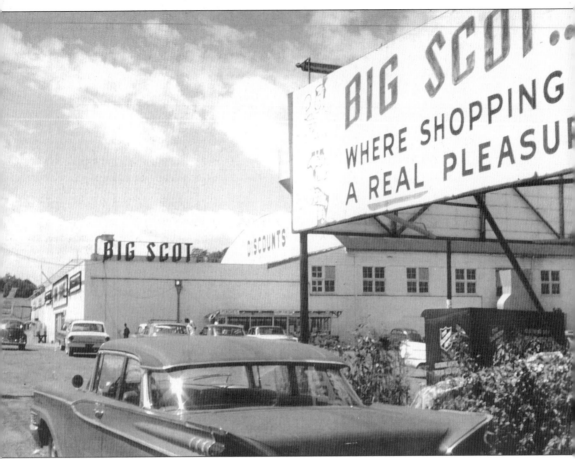

Big Scot was just over the city line on the north side of the Cochecton Turnpike (state Route 17K), the extension of Broadway to the west. It was the first large super discount store in the area and was housed in a former roller rink. Currently, it is the home of another longtime Broadway business, one that moved all the way from the most eastern location to the most western: Ware-House Furniture. It just goes to show no matter how things change, they always remain the same . . . and Broadway, although it may have changed and lost some of its luster, will always remain "the Heart of the City." (Fogarty photograph and collection.)